Historic England

G000075285

Somerset

Andrew Powell-Thomas

AMBERLEY

For my mum and dad, Margaret and Albert, with love

First published 2019

Amberley Publishing
The Hill, Stroud, Gloucestershire, GL5 4EP
www.amberley-books.com

The publisher is grateful to the staff at Historic England who gave the time to review this book.

All contents remain the responsibility of the publisher.

ISBN 978 1 4456 9265 4 (print)
ISBN 978 1 4456 9266 1 (ebook)

British Library Cataloguing in Publication Data.
A catalogue record for this book is available from the British Library.

Typesetting by Aura Technology and Software Services, India. Printed in Great Britain.

Contents

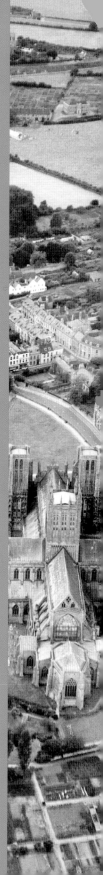

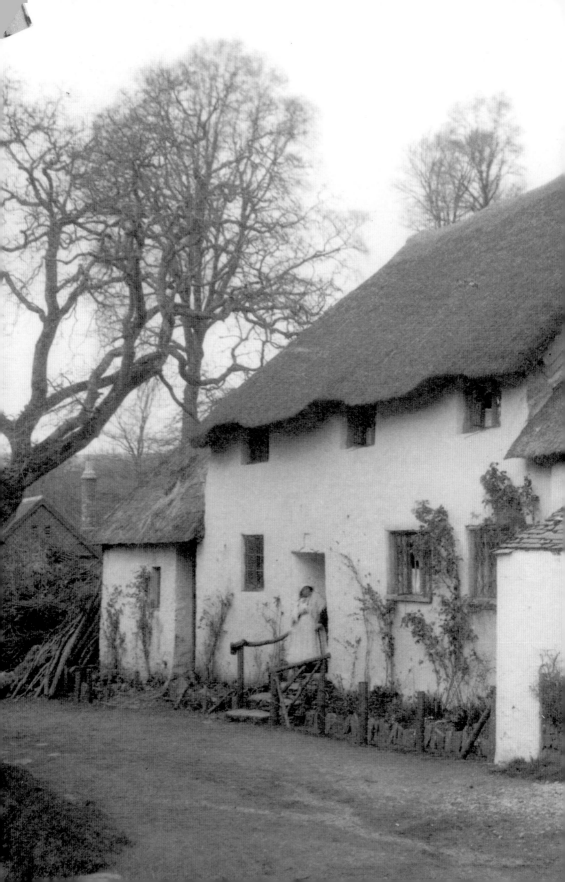

Introduction

As the seventh largest county in the United Kingdom, Somerset is often thought of as a rural backwater with little more than farmland and a few towns to shout about, but it is far from that. Somerset has a proud and varied heritage that includes castles, abbeys and grand buildings, as well as stunning rolling countryside and glorious beaches. The motto of the county, '*Sumorsæte ealle*', means 'All the people in Somerset' – a reference to the support the people of Somerset gave to King Alfred in his struggle to save Wessex from Viking invaders in Anglo-Saxon times. It is from these beginnings that the county stands today. In the aftermath of the Norman Conquest great castles were built across the county to keep the local population in check, and there was much bloodshed on Somerset's soil during the English Civil War and the Monmouth Rebellion. As the Industrial Revolution came so did the development of the county's infrastructure, and by the Victorian era fishing villages became seaside hotspots as tourists flocked to the area in search of the perfect English holiday. The First and Second World Wars saw defences built and many men lost, and in the subsequent years since Somerset has continued to develop and thrive, becoming the beautiful place it is today. Take a step back in time and discover the remarkable history of this proud region.

Towns and Villages

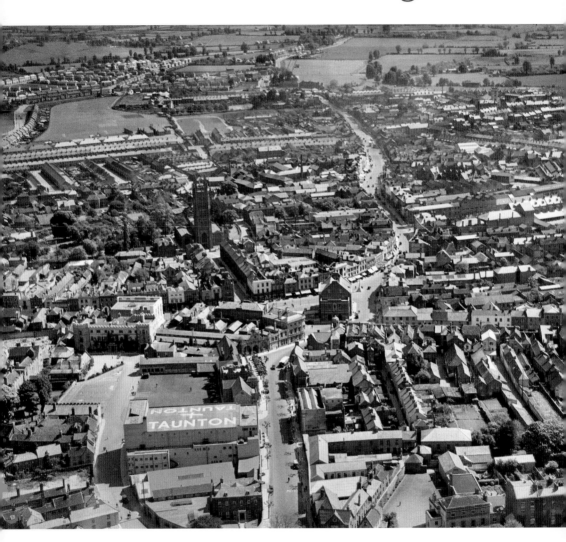

Taunton

Where better to start than with the county town of Taunton, seen here in 1933. Mentioned in the Domesday Book of 1086 and with evidence of human settlement even earlier, it became the administrative centre of Somerset in 1366. The size of the town has grown considerably over the years, with the open fields at the top of the picture long since built upon, but the layout of the town centre has stayed exactly the same. (© Historic England Archive. Aerofilms Collection)

Right and below:
Taunton
The streets of Taunton through the years. This 1901 photograph (right) looking along Hammet Street towards the tower of St Mary Magdalene's Church shows the symmetry and uniformity of Victorian era building. The image of North Street (below), taken sometime between 1930 and 1950, shows the development of the motor car and street lighting – things we easily take for granted these days. (Historic England Archive)

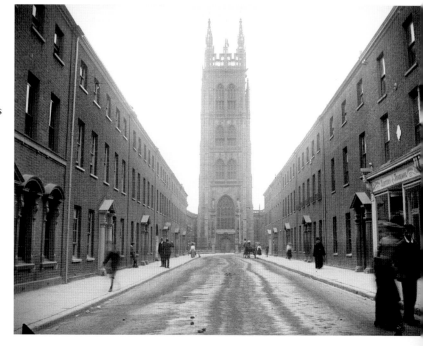

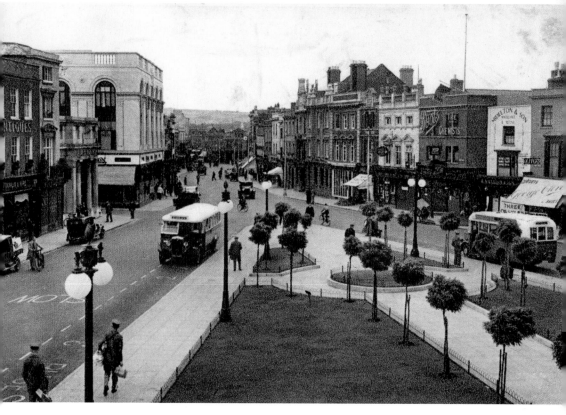

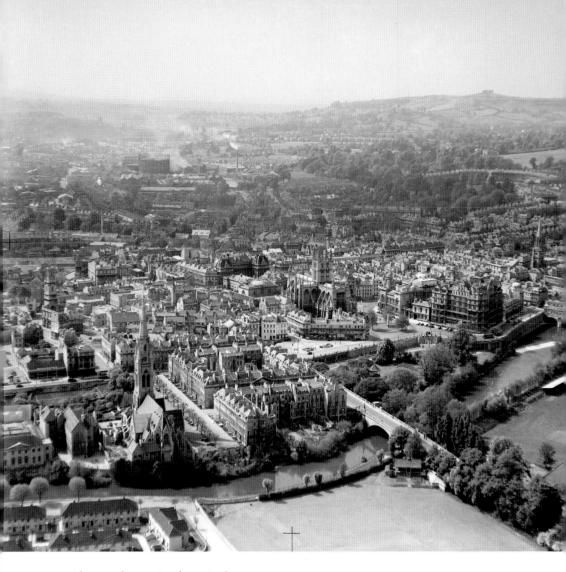

Above and opposite above: Bath

The largest city in Somerset is a tourist hotspot for anyone visiting the West Country. As you meander through the city centre it is impossible not to be impressed with the grand, imposing and elegant structures that are seemingly everywhere. Bath has long been viewed as a cultural and literary centre and as such, over the weekend of 25–27 April 1942, it was heavily bombed by Nazi Germany as part of their Baedeker raids, where cities of cultural significance were targeted in response to the growing success of the RAF's own raids in Germany. Over seventy-five aircraft dropped bombs on Bath that weekend, resulting in over 400 civilians being killed, over 1,000 injured and a staggering 19,000 buildings being affected. The Bath you see now was planned and built in the eighteenth century, with many buildings having grand façades, the most spectacular of which is the Royal Crescent and its numerous Ionic columns separating the town houses, as shown in the second photograph in 1930. In the city centre itself, the beautiful Pulteney Bridge sits astride the River Avon and is one of the few examples in Europe of a bridge specifically designed to also be a shopping arcade. In 1987 Bath became a listed UNESCO World Heritage Site for its Georgian architecture and town planning as well as its Roman archaeology. (© Historic England Archive. Aerofilms Collection; Historic England Archive)

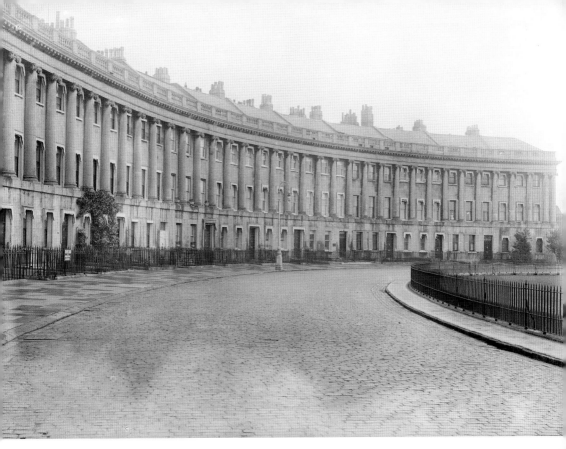

Right: Lansdown Road, Bath
Looking down an empty
Lansdown Road towards Broad
Street in December 1919. The
houses have changed little in
the century that has passed.
(Historic England Archive)

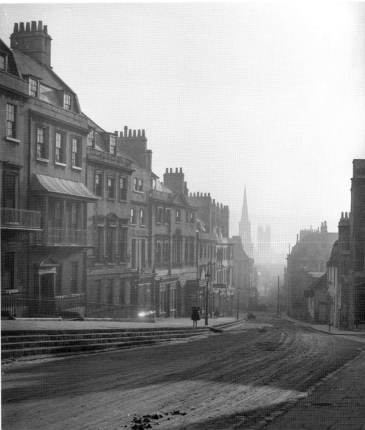

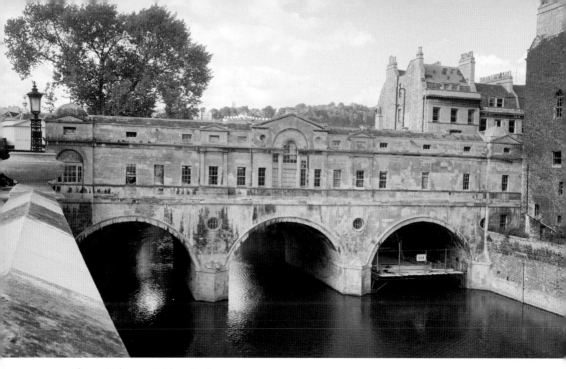

Above: Pulteney Bridge, Bath

The beautiful Pulteney Bridge sits astride the River Avon and is one of the few examples in Europe of a bridge specifically designed to also be a shopping arcade. The bridge was built for William Johnstone Pulteney between 1769 and 1774, being constructed by Robert Adam with limestone. It is lined with shops on the north and south sides and there are three large arches facing downstream. (© Historic England Archive)

Opposite: The Roman Baths

One of the most significant and well-preserved Roman ruins in the country, the Roman Baths in Bath were built after the Roman invasion of Britain, where a temple was constructed on the site of geothermal springs that were a centre of worship for the Celts. With public bathing a staple of daily Roman life on the Continent, it isn't surprising that over the next 300 years a full complex was built up, as Roman engineers created stable foundations and constructed buildings around the hot bath, lukewarm bath and cold bath. The Roman's withdrew from Britain in the fifth century and it seems that the baths fell into a significant state of disrepair. By the twelfth century new buildings were in situ and by the sixteenth century the Queen's Bath was built to the south of the ancient spring by the city corporation. The vast majority of the buildings that we now see were built in the eighteenth century by the father and son architects John Wood the Elder and John Wood the Younger, the designers responsible for the iconic honey-coloured Bath stone that most of the city is built with. As seen in the first photograph (opposite above), every aspect of the Great Bath, aside from its pillar bases with its columns and symmetrical design, was built entirely during this period. The Victorian expansion of the complex saw the town become increasing popular as a spa town, with many social functions happening here. The fact that these public baths are in the middle of Bath certainly adds to the allure of them. Set among the hectic goings on of modern-day life, the tranquillity offered here is hard to surpass (see the photograph opposite below). As one of the greatest religious spas of the ancient world, any visit to Bath isn't complete without stopping here. In 2019 Bath was part of a group of European towns put forward as a transnational 'Great Spas of Europe' World Heritage Site. If inscribed by UNESCO, Bath would be the only British location that is in two World Heritage Sites. (Historic England Archive; © Historic England Archive)

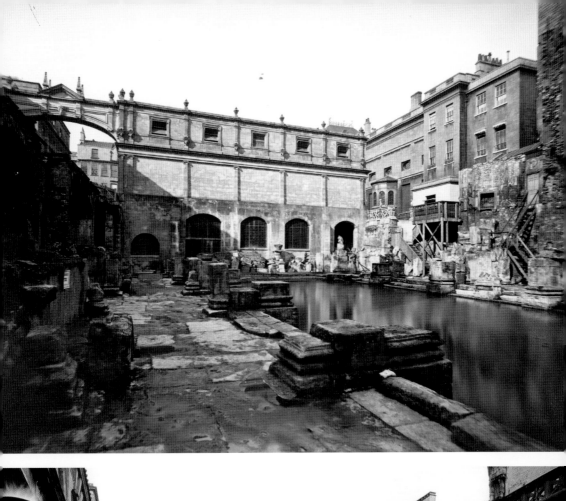
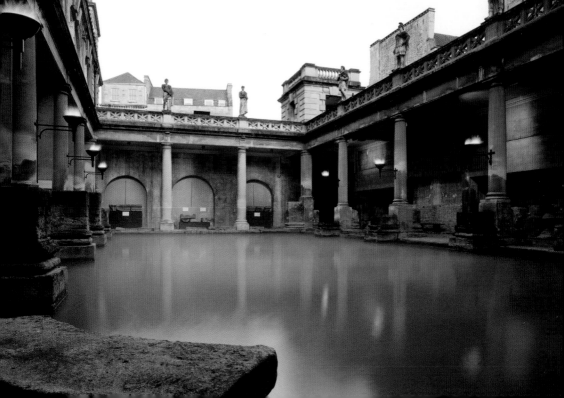

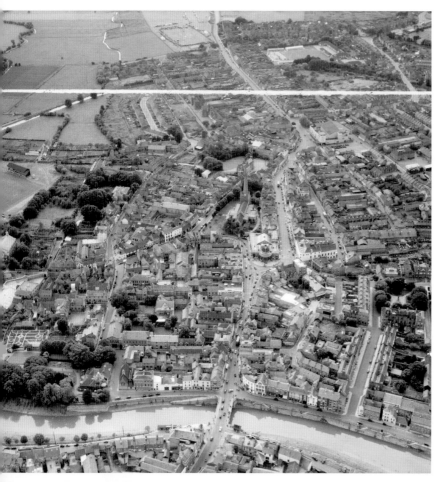

Bridgwater
Bridgwater spans the River Parrett and has been a significant inland port and trading centre since the Industrial Revolution. It is possible to see that the layout of the town centre has changed little over the years, despite Bridgwater's population having doubled since this photograph was taken, although the busy high street is now pedestrianised. (© Historic England Archive. Aerofilms Collection)

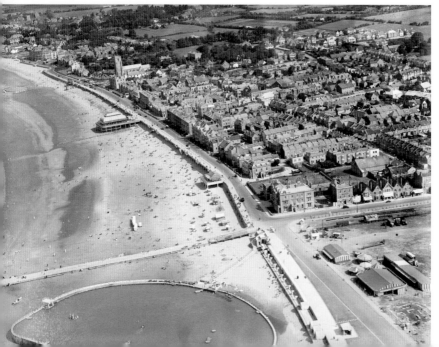

Burnham-on-Sea
A glorious view of the boating pool, beach and town of Burnham-on-Sea. The vast expanses of sand turned this small fishing village into a seaside resort and the pier, which was completed in 1914, has the dubious claim of being Britain's shortest. (© Historic England Archive. Aerofilms Collection)

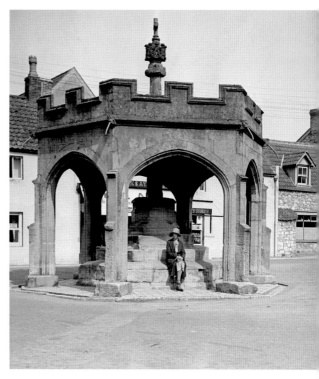

Right and below: Cheddar
The village of Cheddar has been a place of human settlement since Neolithic times, with Britain's oldest complete human skeleton found here in 1903. The village gave its name to Cheddar cheese, and the town saw many watermills and factories established in the seventeenth and eighteenth centuries as it became a centre for clothes production. By the mid-nineteenth century, Cheddar Gorge and caves began drawing in the town's first tourists and this is now the town's main source of income. The town's Grade II listed market cross was originally constructed in the fifteenth century, with its octagonal shelter coming later. It has been the subject of damage in traffic accidents over the recent years, with a 2012 repair costing £60,000. (Historic England Archive)

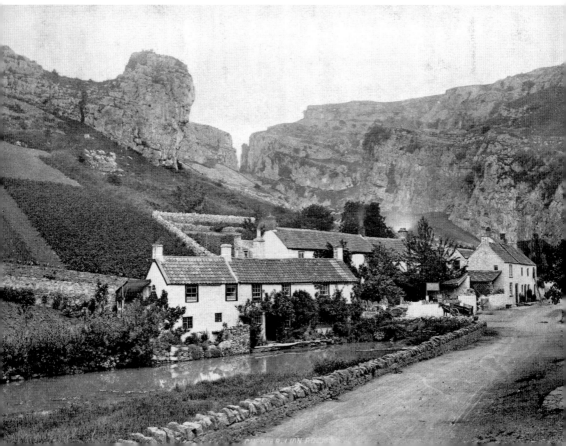

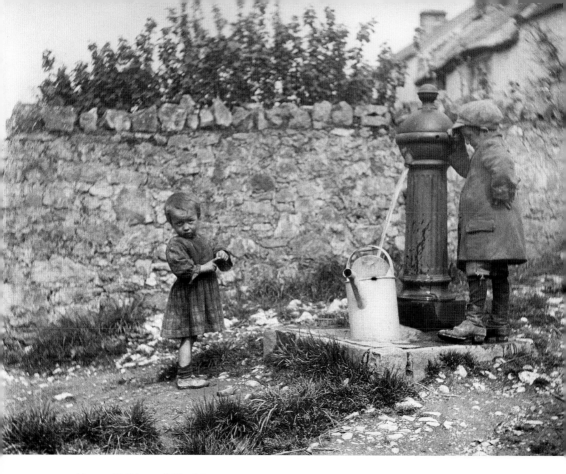

Above: Children of Cheddar

In 1789, William Wilberforce visited Cheddar and saw the poor conditions that the locals lived in. He inspired Hannah More in her work to improve the conditions of the Mendip miners and agricultural workers and she founded a school in the village for the children of miners in the late eighteenth century. You can see in this 1907 photograph that conditions remained difficult for the poor over 100 years later. (© Historic England Archive)

Opposite: Clevedon

Located in north Somerset, just a half an hour from Bristol, Clevedon gained prominence as a Victorian era seaside resort due to its proximity to Bristol. The pebbled beach and low rocky cliffs became popular during the Victorian craze of bathing in the sea, which saw saltwater baths constructed on the waterfront as a result. Although these have now gone, the bandstand and pier (opened in 1869 and one of the earliest surviving examples of a Victorian pier) remain in situ. At over 300 metres long, the pier is managed by the Clevedon Pier Preservation Society, who saved it from being demolished in the 1970s. Sir John Betjeman described Clevedon as 'the most beautiful pier in England'. It is now a Grade I listed building. As well as the pier, the clock tower built to commemorate Queen Victoria's Jubilee in 1898 stands proud in the town. Poets Walk is a popular coastal footpath along the southern end of the town, which is said to have inspired poets such as Alfred Tennyson and Samuel Taylor Coleridge, and with views as far as Wales on a good day it is easy to see why. (© Historic England Archive. Aerofilms Collection; © Historic England Archive)

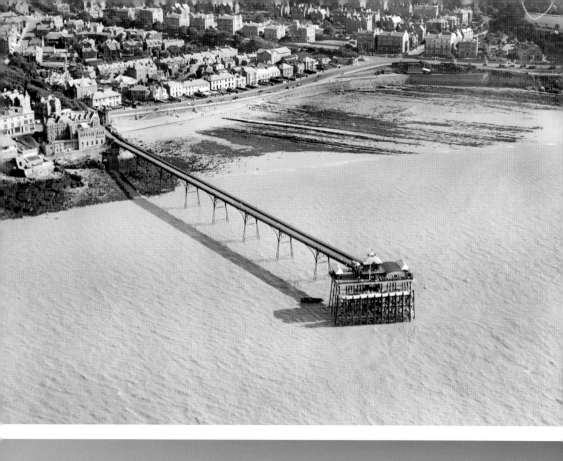
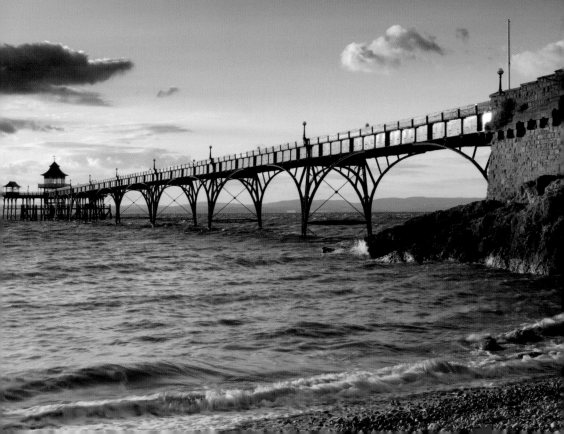

Above: Combe Sydenham

Combe Sydenham is a historic manor house on the edge of the Exmoor National Park that was originally listed in the Domesday Book of 1086, being one of the many manors held by William de Moyon, the Baron of Dunster. It was later one of the homes of the Sydenham family, and is set in 500 acres of estate, including much woodland and parks. (Historic England Archive)

Opposite: Dunster Village and Castle

Surely one of the most splendid sights in the county, Dunster Castle pokes out of the treeline on the top of a steep hill on the outskirts of Exmoor, with its village nestled in its shadow. In the aftermath of the Norman Conquest of 1066, William the Conqueror's tenant-in-chief, William I de Moyon, became the sheriff of Somerset and built Dunster Castle by the time the Domesday Book was compiled in 1086. Originally built of wood, a stone keep was soon built along with towers and many buildings as the castle acted a point of power for the de Moyon family for the next 400 years. In the aerial photograph, taken in 1930, it is easy to pick out St George's Church. The lower photograph, taken between 1850 and 1900, gives a view from the north of the Grade I listed Dunster Yarn Market, which was constructed in 1609 as a way of maintaining the importance of the village as a market, particularly for wool and cloth. It is interesting to note the man painting on an easel, the horses and the castle looming in the distance. To this day, the Yarn Market still bears the damage caused by cannon fire in the Civil War. (© Historic England Archive. Aerofilms Collection; Historic England Archive)

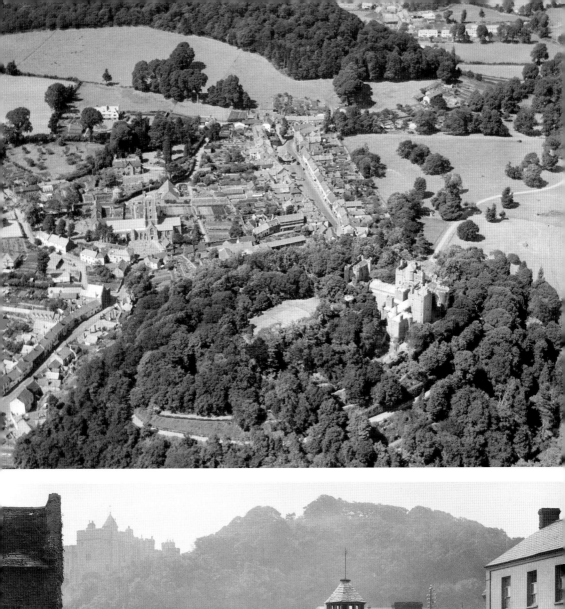
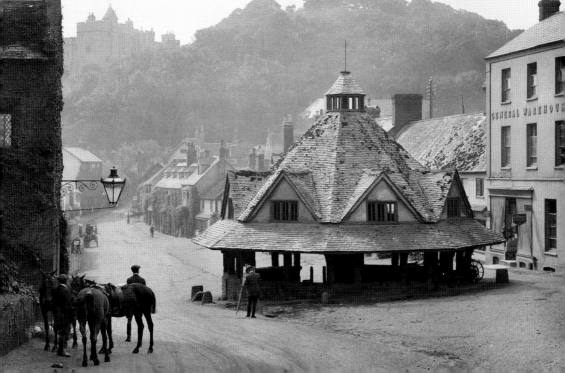

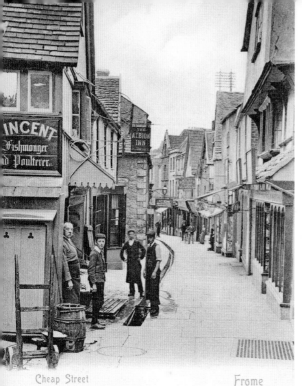

Cheap Street Frome

Left: Frome
The manufacture of woollen cloth was the town's principal industry in the fifteenth century, but by the mid-eighteenth century the decline of the wool industry, coupled with increased industrialisation and rising food prices, led to poverty and some unrest among the inhabitants of Frome. This photograph shows Cheap Street at some point between 1880 and 1916. (Historic England Archive)

Below: Public Offices Building, Frome
Frome Town Council bought the 1892 Public Offices building from Somerset County Council to be used as their new town hall. The distinctive clock face on the front façade still exists today. (Historic England Archive)

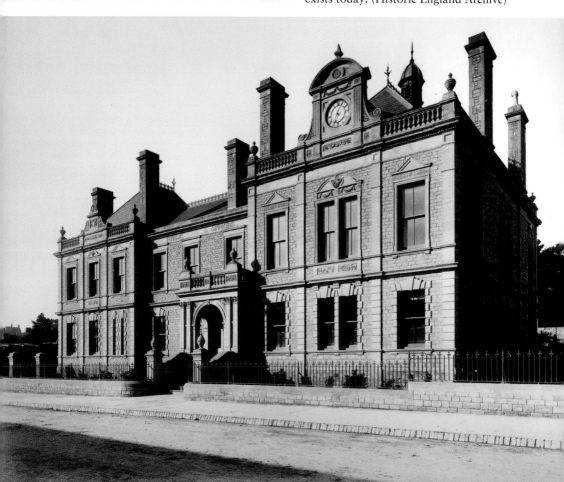

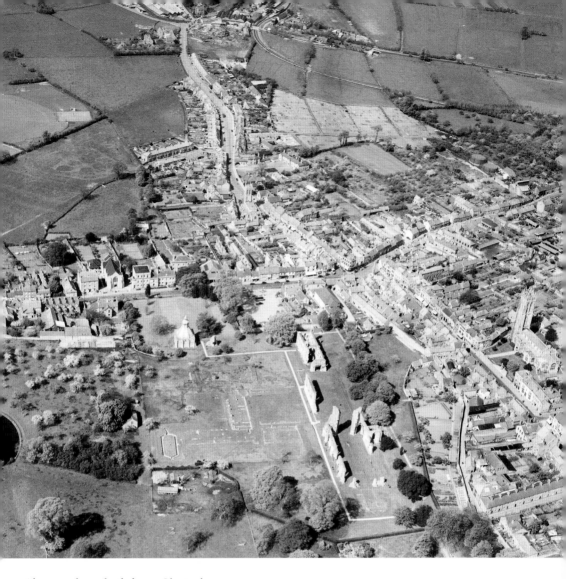

Above and overleaf above: Glastonbury

Myths, legends and ruins, the town of Glastonbury has them all. Located right in the middle of the town itself is Glastonbury Abbey, which has been a place of pilgrimage for many and so much more than just a set of stone relics. It has dominated the town for the over 700 years and is rightly regarded as one of the most important abbeys in England, being the site of Edmund Ironside's coronation as King of England in 1016. With the construction of the market cross (seen in the second photograph in 1898), Glastonbury Canal and the Glastonbury and Street railway station, the town became a centre of trade and commerce. It is the abbey, however, that still takes centre stage and this is evident in the 1948 aerial view of the town (above). Nestled in among the modern-day buildings of Glastonbury, it is hard not to be impressed with the grandeur of what remains of the site and the grounds in which they stand as you head up the path to the abbey gatehouse. (© Historic England Archive. Aerofilms Collection; Historic England Archive)

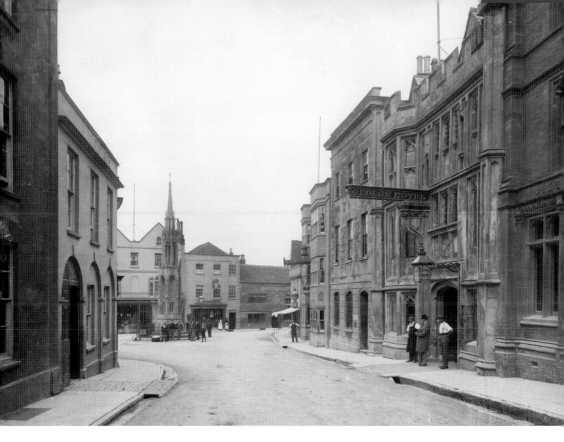

Below: Luccombe
The village of Luccombe in the Exmoor National Park is located at the foot of the moor's highest hill and was recorded in the Domesday Book of 1086. This image shows the thatched cottages in this peaceful village at the turn of the twentieth century. (Historic England Archive)

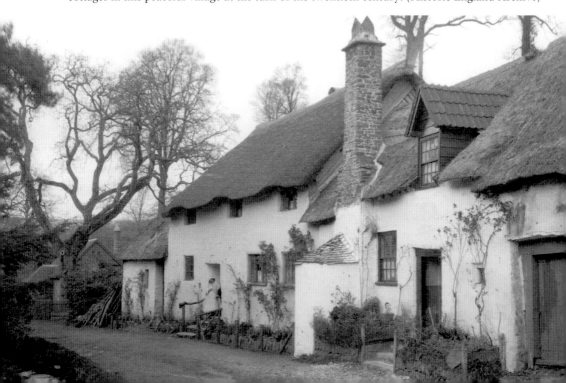

Midford
Two men in a horse-drawn cart about to cross the Midford Bridge, with the railway line in the background. The small village of Midford extends over both Somerset and Wiltshire. (Historic England Archive)

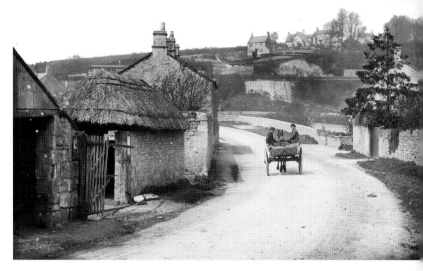

Minehead
Minehead of the 1920s still had a relatively small promenade compared with today. However, the vast beach and development of the railways saw the town rapidly expand, particularly with the Butlins holiday resort that was opened in the town in 1962, offering families the opportunity of a beach holiday in this country at a reasonable price, with plenty of entertainment. (Historic England Archive)

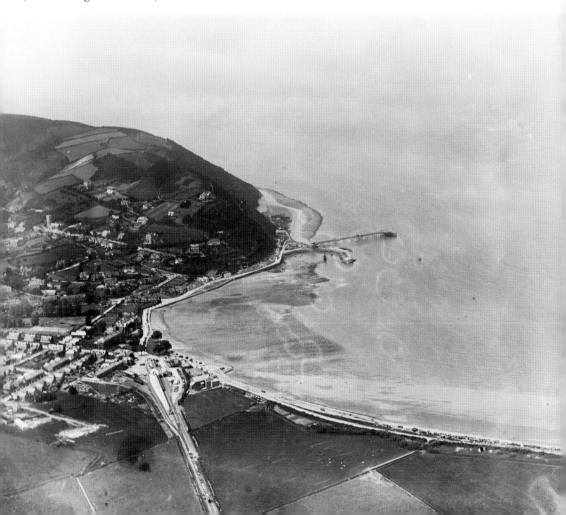

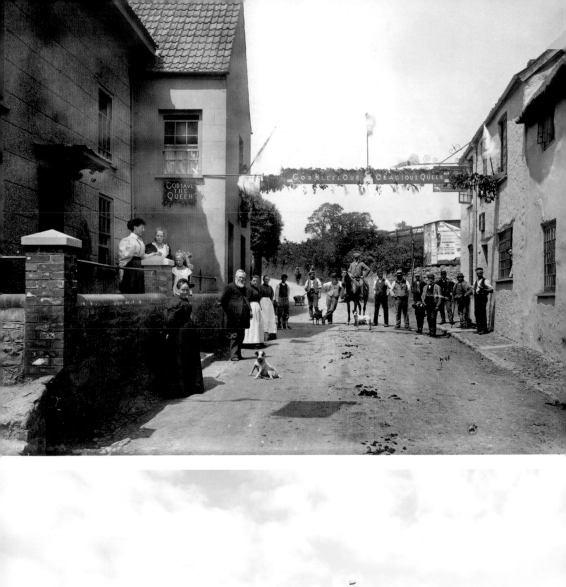
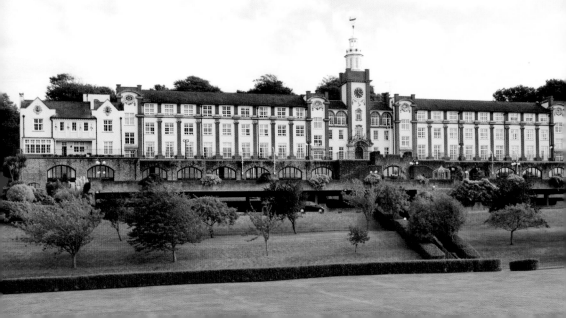

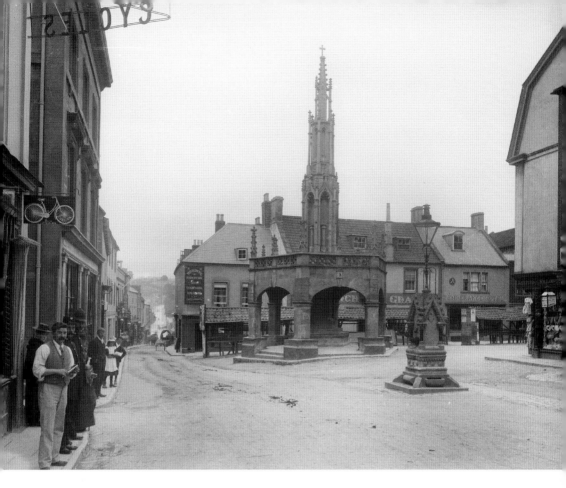

Above: Shepton Mallet

Shortly after the Norman Conquest the town was passed to the Malets, an important Norman family who placed their name after that of the settlement (doing the same to Curry Mallet). In the middle of the town is the Grade II listed market cross, a beautiful octagonal structure that was the central point to life in the town during the Middle Ages, originally constructed in the year 1500. This was also a rather grisly place, as in the aftermath of the Monmouth Rebellion in 1685, twelve local men from the town were hanged and quartered as a warning to others who opposed to the king. A public water fountain can also be seen in this photograph from 1898. (Historic England Archive)

Opposite above: Queen Victoria's Diamond Jubilee, Nether Stowey

The people of Nether Stowey standing under banners celebrating Queen Victoria's Diamond Jubilee at the north end of Lime Street. The public house is on the right and Coleridge's cottage is on the left. (Historic England Archive)

Opposite below: Portishead Nautical National School

Created in 1869 for neglected and destitute boys, the school was originally based on HMS *Formidable*, which was moored off the shore, until it moved into this mammoth 2-acre onshore site in 1906. The inside was made to simulate that of a ship, with wooden floors and hammocks to sleep in. The school provided the boys with a range of skills required for seamanship and eventually closed in 1983. The Grade II listed building is now part of a private gated community. (© Historic England Archive)

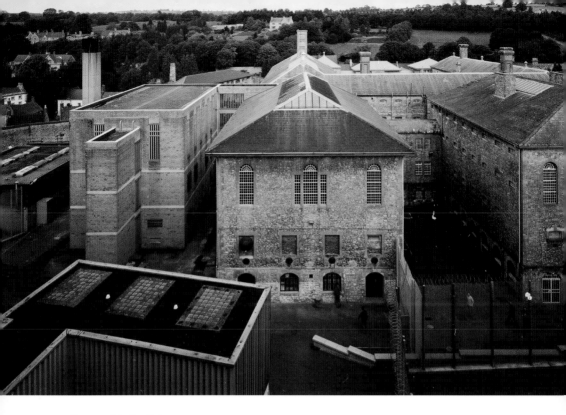

Shepton Mallet Prison

Opened in 1625, HMP Shepton Mallet was used right up until the 1930s, primarily for civilians, when it was temporarily closed due to low prisoner numbers. However, at the outbreak of the Second World War it was reopened for British military use, mainly to billet soldiers, but it was then handed over to US forces in 1942, who used it for the next three years to incarcerate military personnel who had committed offences. During this time, eighteen service personnel were executed inside the prison. At the same time, in a different part of the prison and unbeknown to most, a number of important historical items from the Public Record Office in London were transported here for safekeeping during the conflict. Items such as the Domesday Book, a copy of Magna Carta, letters from the Battle of Waterloo and the logbooks of HMS *Victory* were held here until the end of hostilities. After the war the prison remained open, with the infamous Kray twins being held here in the early 1950s after deserting the British Army. The prison closed in 2013 and plans for its conversion to residential use have been agreed. (© Crown copyright. Historic England Archive)

Somerton

A view of the drinking fountain and water trough on Broad Street in Somerton. The town was an important political and commercial centre in Anglo-Saxon times, and was possibly the capital of Wessex in AD 900. In the fourteenth century it was the county town of Somerset, but in the years that followed its status waned to that of a market town. (Historic England Archive)

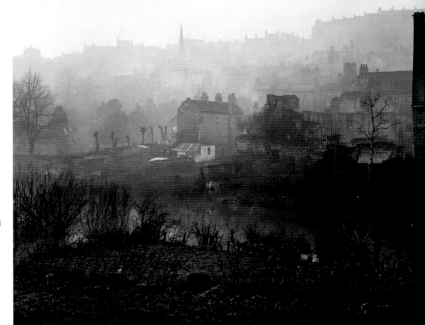

Walcot
A misty view looking west across the River Avon from the north end of St John's Road, with Walcot Church in the distance. Walcot is a suburb of the city of Bath and developed as a residential area during the Roman occupation of the town in the first to third centuries. (Historic England Archive)

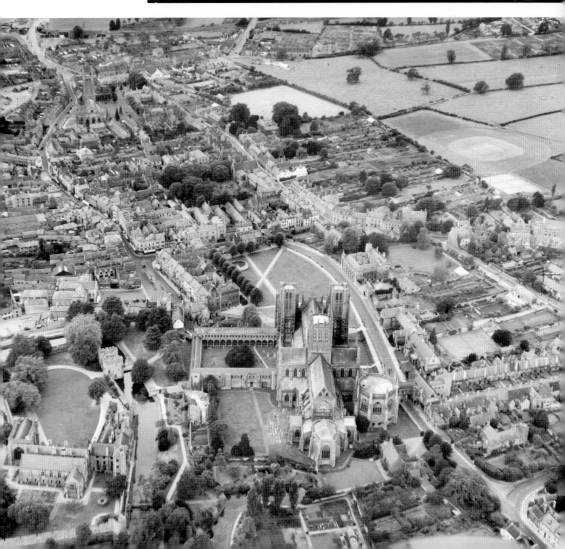

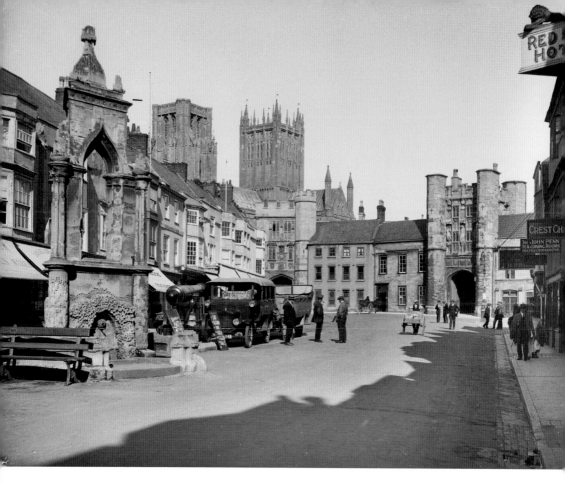

Above and previous page below: Wells

The cathedral city of Wells, the smallest city in the country, started out as a Roman settlement and grew in importance under the Anglo-Saxons, who built the first church here in 704. From then on the city has spent much of its existence closely linked to the cathedral and the bishops of the diocese of Bath and Wells. This gave the city a strong link to the monarchy and in the English Civil War of 1642–51, Parliamentarian soldiers surrounded the city in what became known as the Siege of Wells, forcing the Royalists to leave the city. A few years later, during the 1685 Monmouth Rebellion, rebels fighting against the king saw the grand cathedral as a symbol of all that was wrong with the 'established order' and attacked it, breaking windows, destroying the organ and using the lead roofing to make bullets. However, retribution was swift from the king, and Judge Jeffreys held the last of his Bloody Assizes in the city, where over 500 of the rebels were put on trial for treason. Lasting just one day, the vast majority were found guilty and sentenced to death on the same cobbled streets you still walk along today. With its population of just 10,000, Wells certainly doesn't feel like a city. It retains its old-world charm thanks to its tiny streets, grand buildings and a feeling that life here moves at a slower pace than the hectic modern world we live in. The first photograph is an aerial view of the city in 1947, while in the second photograph, taken in 1921, you can see the market cross in the foreground and the towers of St Andrew's Cathedral in the background. (© Historic England Archive. Aerofilms Collection; Historic England Archive)

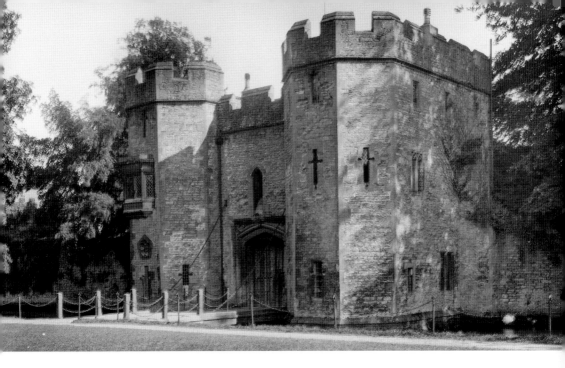

Above and below: Bishop's Palace, Wells

Built in 1210 by Bishop Jocelin of Wells and Bishop Reginald Fitz Jocelin, the Grade I listed Bishop's Palace has been home to the bishops of the diocese of Bath and Wells for 800 years. Originally surrounded by a medieval deer park, the chapel and great hall were added by Bishop Robert Burnell by 1292, with the walls, gatehouse and moat that you see today added in the fourteenth century. The palace was used as a garrison for troops in both the English Civil War and Monmouth Rebellion after which it was used as a prison for rebels after the Battle of Sedgemoor. Today, parts of the palace are still used by the bishops, while the buildings also act as a large tourist attraction. It is hoped to provide public access to the walks on the top of the Great Hall walls as part of an ongoing conservation project. (Historic England Archive; © Historic England Archive)

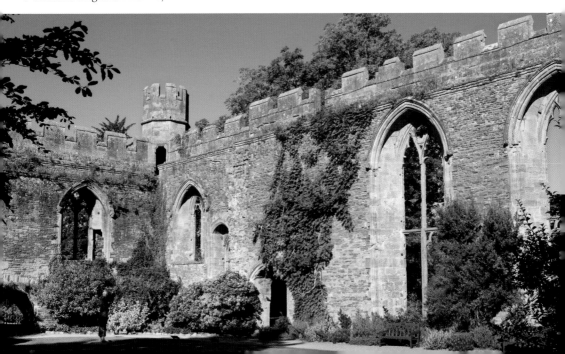

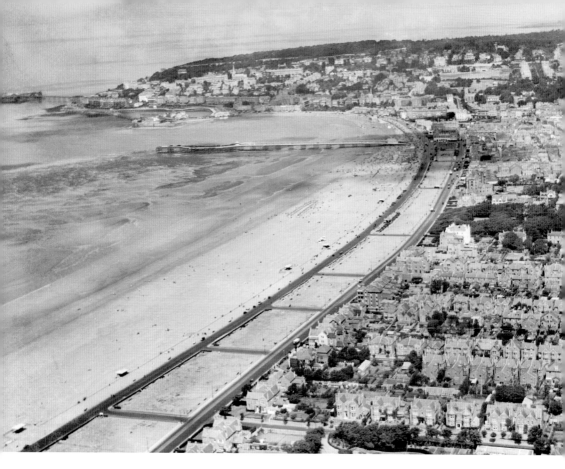

Above: Weston-super-Mare
The sprawling beaches of Weston-super-Mare have long been a draw for many visitors. In this aerial photograph from 1930 you will notice the hundreds of people around the entrance to the Grand Pier, the distinct lack of traffic on the roads and the fact that the Grand Pier is lacking any structures at the end – due to fact it had been ravaged by fire earlier that year. (© Historic England Archive. Aerofilms Collection)

Opposite above: Weston-super-Mare
A fascinating photograph of two women walking towards a group of children who are stood on the road in front of Atlantic Terrace East on Atlantic Road. The houses might not have changed, but clothes certainly have! (Historic England Archive)

Opposite below: Birnbeck Pier, Weston-super-Mare
Weston-super-Mare doesn't just have one pier. Birnbeck Pier was opened in 1867 and linked Birnbeck Island to the mainland. Locals and tourists used the pier, which was full of amusements, and steamers frequently stopped here as it provided an excellent stop along the Bristol Channel. A lifeboat station was built here due to the extreme tidal range of the Bristol Channel, and this photograph shows a lifeboat being launched. The Second World War saw the pier requisitioned by the Admiralty for it to be used in the development of new weaponry, and although the pier resumed its role as a tourist attraction after the war, competition from Weston's Grand Pier saw its business decline, with it eventually closing in 1979. The pier is one of the most vulnerable buildings on Historic England's national register of Heritage at Risk and discussions about its future are ongoing. (Historic England Archive)

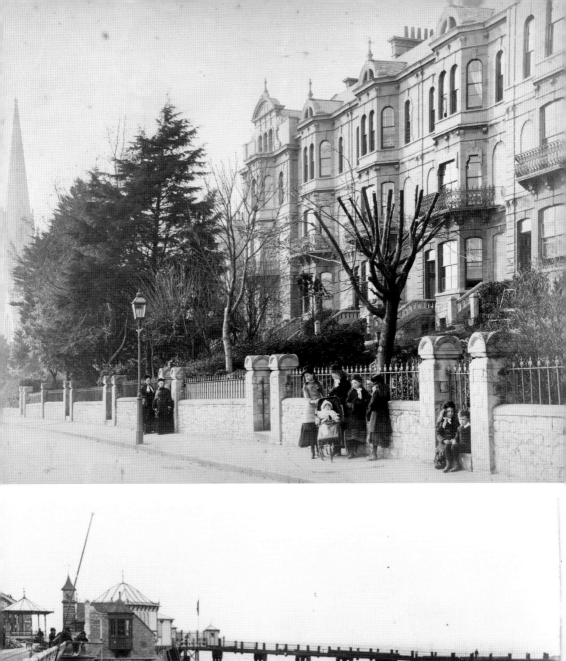
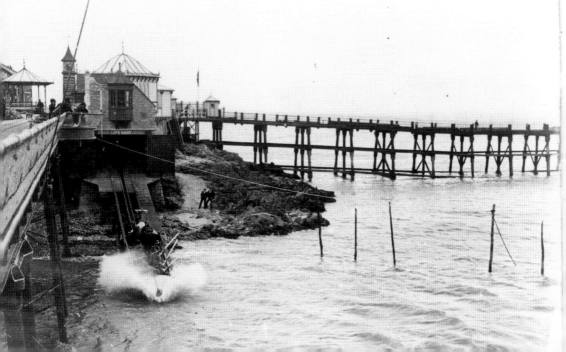

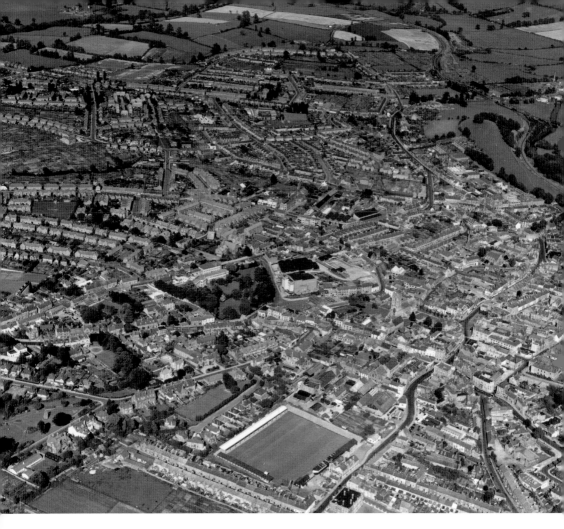

Yeovil
Yeovil is one of Somerset's largest towns and has grown steadily over the years. In the foreground the Huish Athletic Ground can be seen, famous for its 8-foot side-to-side slope and home to Yeovil Town FC for a number of years until they moved to the newly built Huish Park in 1990. (© Historic England Archive. Aerofilms Collection)

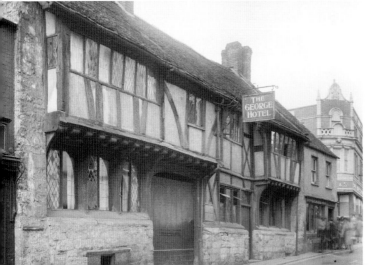

The George Hotel, Yeovil
Built in 1478, The George Hotel was located on the south side of Middle Street and served the town until the early twentieth century, when it was then sold to a Salisbury brewing company. It was demolished in 1962 as part of a road-widening scheme. (Historic England Archive)

Industry and Commerce

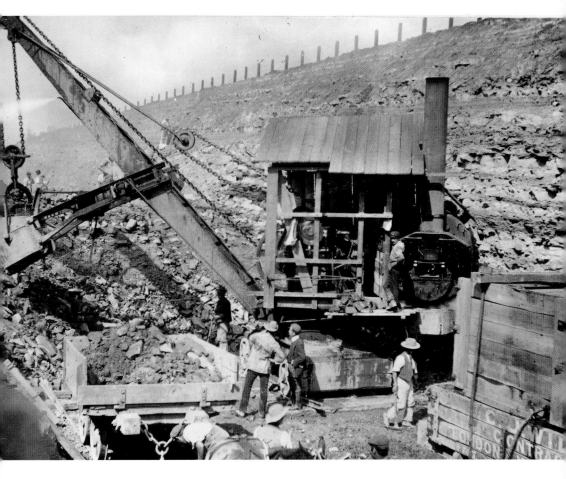

The Railway Boom
The Industrial Revolution of the early nineteenth century saw the development of steam power and thus began the railway boom of the 1840s. Here a steam excavator is making a cutting during construction work for the Langport & Castle Cary Railway, sometime between 1900 and when the first section was opened in 1905. (Historic England Archive)

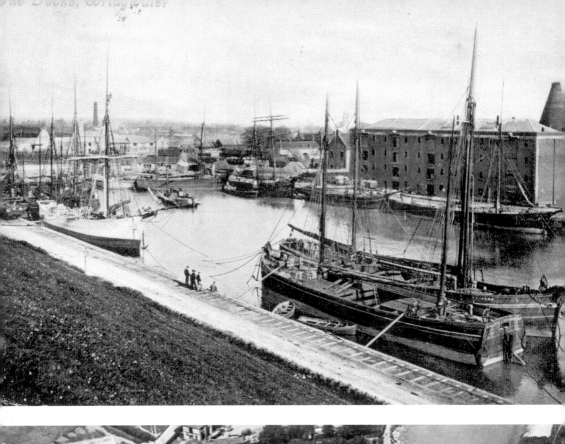

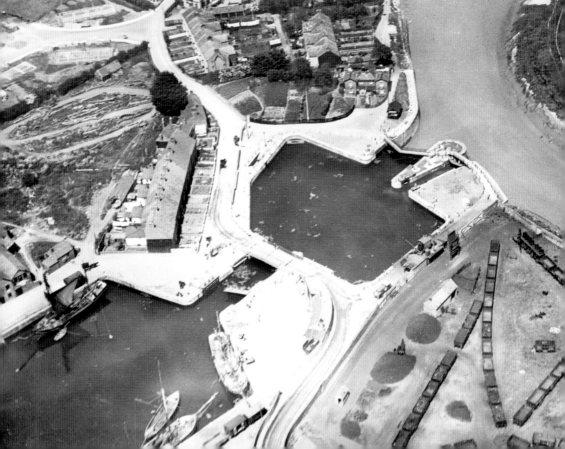

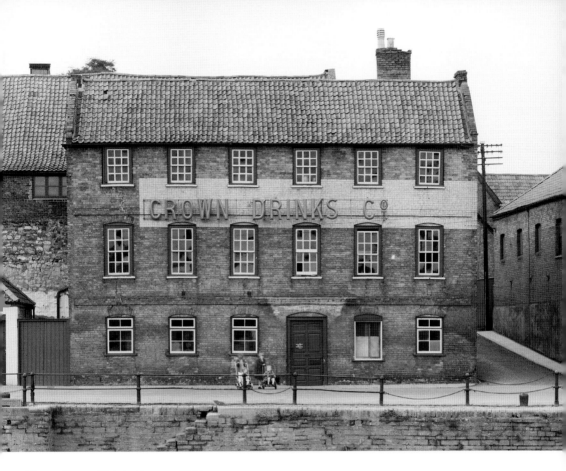

Above: Crown Drinks Factory, Bridgwater
Making the most of the transport facilities provided by Bridgwater Docks, the three-storey Crown Drinks Co. factory at No. 14 West Quay in Bridgwater was a place of employment for many within the town. Although the building remains, its use has now changed, providing two shopfronts and residential dwellings above. (Historic England Archive)

Opposite: Bridgwater Docks
Opened in 1841, the docks at Bridgwater provided better facilities for larger boats to berth in either the newly constructed outer basin or the inner basin – joined by a series of locks. By 1853 traffic had increased to nearly 2,500 vessels a year, but with the development of the railway this started to decline by the late 1880s. The first photograph, taken in 1898, shows that the docks were still a busy place, and the locks are clearly evident in the 1929 aerial photograph. (Historic England Archive; © Historic England Archive. Aerofilms Collection)

ROF Bridgwater

To the north-east of Bridgwater, by the village of Puriton, was the gigantic 700-acre Royal Ordinance Factory Bridgwater, which was a vitally important factory producing high explosives for munitions in the Second World War. By August 1941 the factory was producing RDX, an experimental new explosive more powerful than TNT and widely used by all sides throughout the remainder of the war. The factory had its own railway branch line and required a year-round supply of an incredible 4.5 million gallons of water per day, provided by a new 5-mile-straight channel known as the 'Huntspill River'. After the war, the site continued to produce a range of explosives, before being privatised in 1985 and closing in 2008, when the buildings were demolished. (© Crown copyright. Historic England Archive)

Bridgwater & Taunton Canal

The Bridgwater & Taunton Canal meanders for 12 miles, linking the River Parrett and the town of Bridgwater to the River Tone and Taunton. Originally opened in 1827, the canal saw large amounts of coal and stone being transported, but as the competition from railways increased the canal went into decline. During the Second World War the canal itself was part of the Taunton Stop Line – a defensive line designed to repel any German advance in the West Country. At over 12 feet wide (3.5 metres) it would be an immoveable object that would need to be crossed and, as such, all eleven of the existing brick-built permanent bridges were mined with demolition chambers that would be ignited should they look like being compromised. Although now filled in, these chambers and a large number of pillboxes are still visible today, and the freshwater canal itself is a haven for a wide array of wildlife, both in and out of the water. At the Canal Centre it is possible to hire a barge and while away a few hours punting up and down at a leisurely pace, which is the only traffic that this once busy canal sees. These days there are seven working locks to marvel at and the canal's towpaths form part of the Sustrans National Cycle Network, which connects Bath and Cornwall, and this is now a busier route for cyclists than barges. (Author's collection)

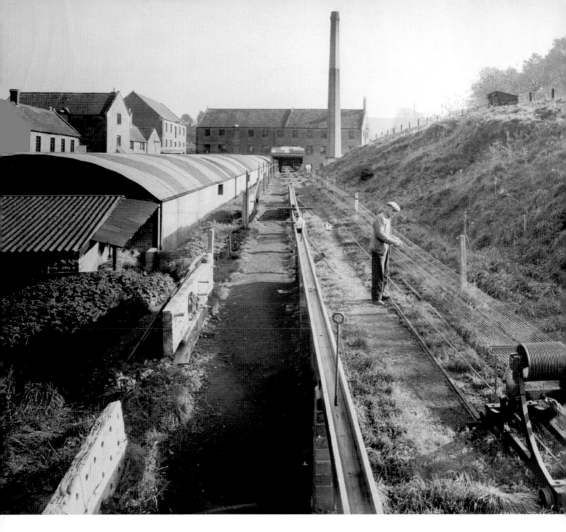

Above: Higher Flax Mills, Castle Cary

Built from 1870 onwards by T. S. Donne, the Higher Flax Mills in Castle Cary were used for the production of warp threads for horsehair fabric, twine and rope. The Castle Cary mills were forced to turn to powered machines after child labour was stopped by the 1870 Education Act. This photograph shows the 'the rope walk', a long straight narrow lane where long strands of material are laid before being twisted into rope. (Historic England Archive)

Opposite above: Gifford Fox & Co. Ltd, Chard

Built between 1820 and 1830, this large factory was constructed by Gifford Fox & Co. Ltd, who produced lace and plain nets for a number of years. Although now used as industrial units, the original projecting hoist remains at one end. (© Historic England Archive)

Opposite below: Clevedon Station

Clevedon station was opened in 1847 as a wooden structure, but as the town developed its reputation as a seaside getaway location, the platform and buildings were improved and rebuilt in 1890, allowing more visitors each year to the town. Road use increased in the years following the Second World War and by the 1960s the station was deemed no longer viable, being demolished in 1968. It was situated at what is now Queen's Square shopping precinct, which was built in the 1980s. (Historic England Archive)

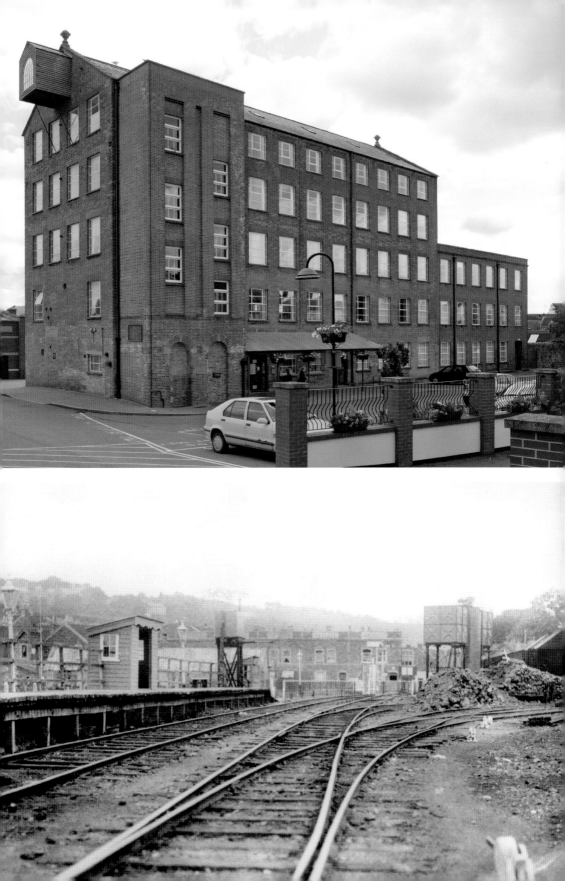

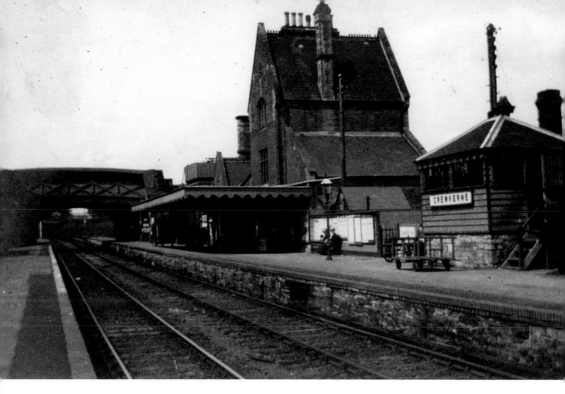

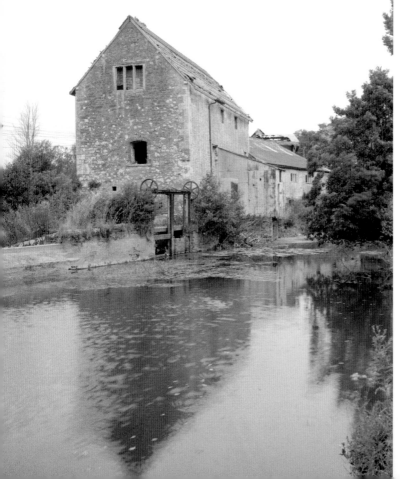

Above: Crewkerne Station
Opened in 1860, Crewkerne station was part of the then brand-new LSWR Yeovil & Exeter Railway. The main building, designed by Sir William Tite, still stands today as a Grade II listed structure, while the (now disused) signal box, built in 1960, can still be found on the site along with a number of other buildings. The station itself is still operational. (Historic England Archive)

Left: Wallbridge Flour Mill, Frome
Flour mills were essential for providing a regular food source for the population, using the power of water to turn wheels to grind wheat into flour. (© Crown copyright. Historic England Archive)

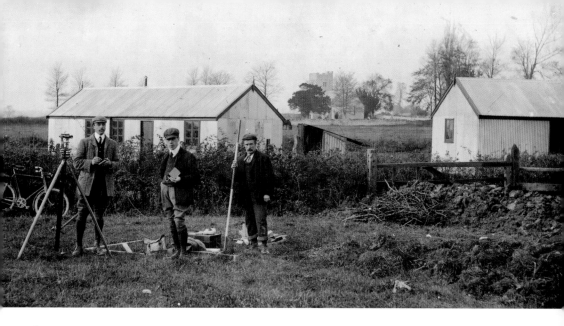

Above: Keinton Mandeville
Construction was much different at the beginning of the twentieth century compared to now, with much more manual labour being needed and health and safety being relatively unheard of. Here is a view of three surveyors in front of temporary site offices to the east of St Mary's Church in Keinton Mandeville during construction work for the Langport & Castle Cary Railway, which is still in use today. (Historic England Archive)

Below: Midsomer Norton Station
The station at Midsomer Norton was opened in 1874 as an extension from Evercreech Junction to Bath. The station operated until 1966 when it closed under the Beeching restructuring of railways across the country. The Somerset & Dorset Railway Heritage Trust leased the station in the mid-1990s, restored it to its 1950s condition and run it as a railway centre and museum. (Historic England Archive)

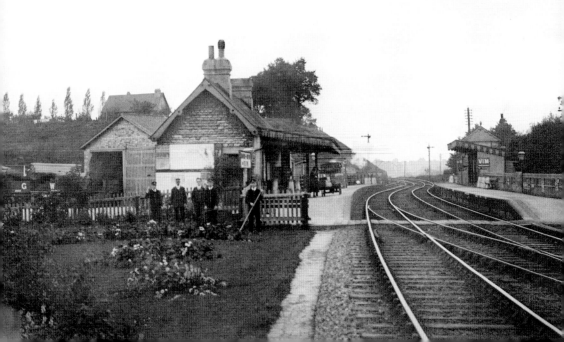

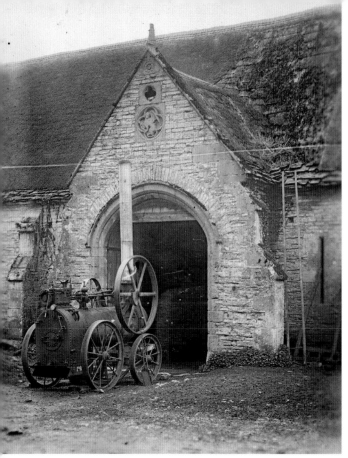

Left: A Portable Steam Engine, Pilton
A fantastic photograph showing
a portable steam engine that
could be used to power any of
the several types of machine that
became common on farms in
the late Victorian era. Taken at
Tithe Barn, Cumhill Hill, Pilton.
(Historic England Archive)

Below: Stacking Peat in Shapwick
Two men stacking peat to dry in
a field in Shapwick. It is stacked
in such a way so that air can
circulate around the blocks and
dry them, after which it can then
be stored away for later use.
(Historic England Archive)

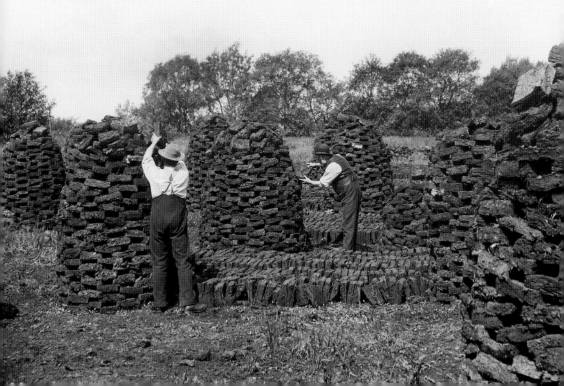

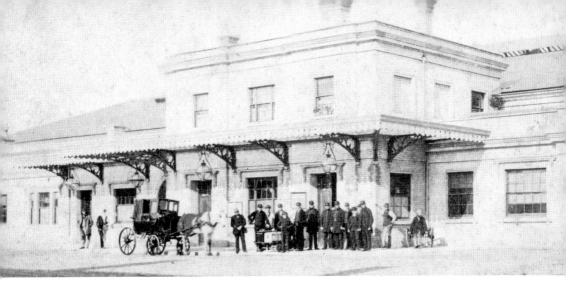

Above: Taunton Station
Originally opened on 1 July 1842, this photograph shows a horse-drawn carriage and a group of porters standing outside Taunton station sometime between 1860 and 1900. Isambard Kingdom Brunel's original design was for a single-sided station with two platforms, but this has been greatly altered since as railroad traffic became busier. The buildings was restored in 2019 using a grant from the Railway Heritage Trust. (Historic England Archive)

Below: Porlock Weir
Porlock Weir lies just under 2 miles from the village of Porlock, and this tidal harbour has over a thousand years of history behind it – the Danes raided it in AD 866. During the eighteenth and nineteenth centuries coal from Wales was the main cargo. This picture shows some moored boats at low tide. The harbour is now used primarily for pleasure yachts. (Historic England Archive)

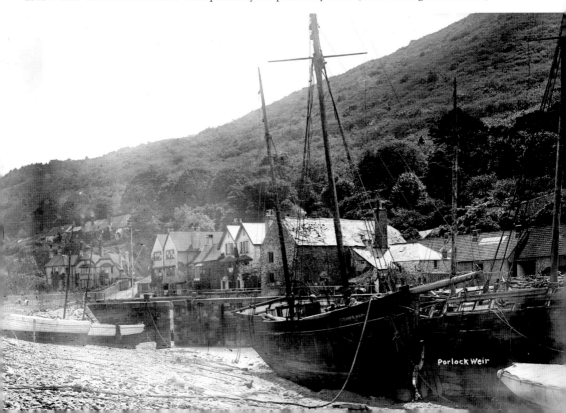

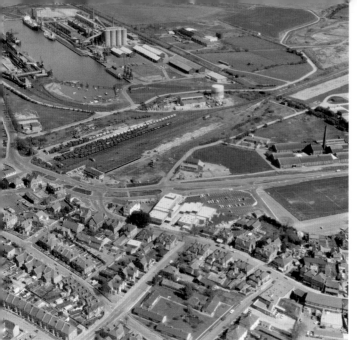

Portishead Dock and Railway Line
Located on the Severn Estuary close to Bristol, it is unsurprising that the Portishead Dock and Railway Line expanded rapidly during the early nineteenth century, with the dock area growing significantly and managed as part of the Port of Bristol. A power station and chemical works were added in the twentieth century, but the dock and industrial facilities closed in the mid-1970s and have been redeveloped into a marina and residential area. It is proposed to reopen the railway line to passanger traffic by 2022 to ease traffic problems in the area. (© Historic England Archive. Aerofilms Collection)

Portishead 'B' Power Station
Portishead Power Station began generating power in 1929 and was later expanded to include an additional 'B' power station in the 1950s. Both were coal powered, although one third of station B was oil powered. Power Station B was decommissioned in the 1980s and since then the whole site has been raised to the ground and redeveloped as housing. (© Historic England Archive. John Laing Collection)

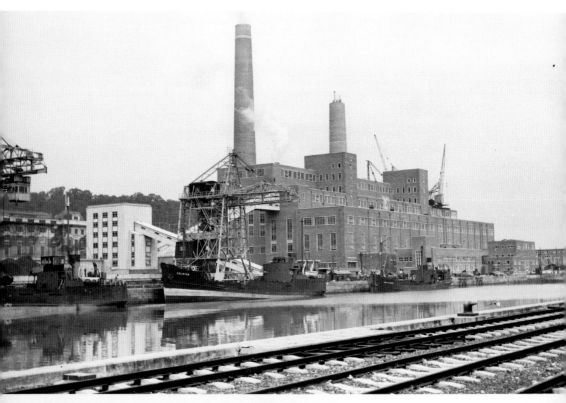

PORTISHEAD "B" POWER STATION.
No. 1060. General—View from East Side of Dock (1). 2/10/56.

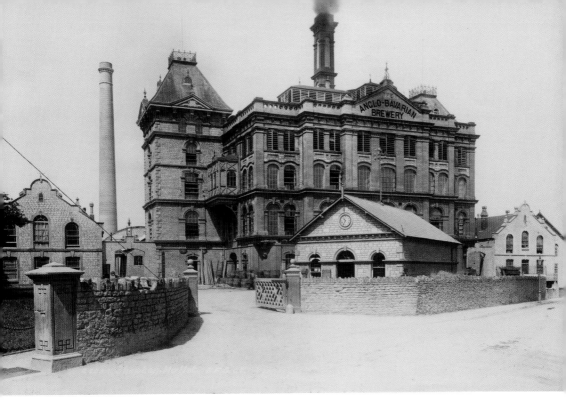

Anglo-Bavarian Brewery, Shepton Mallet
Built in 1864, the Pale Ale Brewery was sold in 1872 and renamed the Anglo-Bavarian Brewery. By the mid-1870s it was brewing pale ale, mild ale, strong ale, porter, stout and amber ale. By 1890 the brewery employed over 200 people from the town and exported 1.8 million bottles per year. Following the outbreak of the First World War in 1914 the inclusion of the word 'Bavarian' on the label of the brewery's bottles led to them being removed from shop shelves throughout the United Kingdom and overseas, thus leading to the decline of the company. (Historic England Archive)

Clarks Shoe Factory, Street
A Quaker family, the Clarks started a business in the late seventeenth century in rugs, woollen slippers and, later on, boots and shoes. Here is a 1946 aerial view of the C. & J. Clark Ltd Boot and Shoe Factory that dominated the town and its High Street for years. In 1993, it was decided that shoes would no longer be manufactured there and the redundant factory buildings were converted to form Clarks Village, the first purpose-built factory outlet in the United Kingdom. C. & J. Clark still has its headquarters in Street. (© Historic England Archive. Aerofilms Collection)

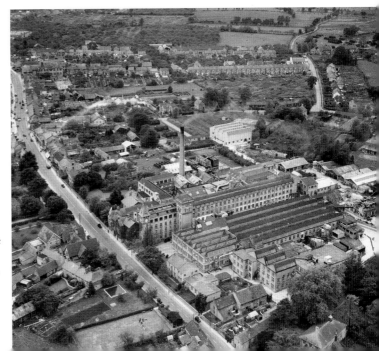

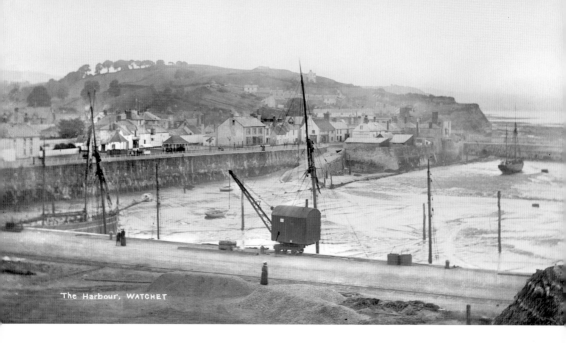

The Harbour, WATCHET

Watchet Harbour

There has been a harbour at Watchet for as long as anyone can remember, and from the mid-1500s onwards the port was used for the import of salt and wine, primarily from France. In 1659 the jetty was damaged in a storm and eventually rebuilt in 1708 by a leading wool merchant who needed to export his goods. By 1862 a new pier and wharf was completed to cope with increased trade in locally produced iron ore, paper and flour. After the Second World War the harbour continued to be used for trade, but ceased operating for commercial use in 2000, with the harbour now being converted into a marina for pleasure boats. (Historic England Archive)

Wellington

The town of Wellington has relied on a number of industries over the years, using the rail, road and water links it has. Although the main industry was wool making, Wellington was also home of Fox, Fowler & Co., which was the last commercial bank permitted to print their own banknotes in the country. The Tonedale Mill Complex has been regenerated in recent years and this photograph, taken in 1995, shows the reservoir water softner engine house. (© Crown copyright. Historic England Archive)

The Pumping Station, Westonzoyland
The first mechanical pumping station on the Somerset Levels was built in 1830 to drain the area around Westonzoyland, Middlezoy and Othery, which was prone to severe flooding. In 1861 a better method was sought, and an Easton & Amos pump (currently on view in the Pumping Station Museum) was installed. The pump operated until 1951 when a new diesel pump in a nearby building made the steam pump obsolete. The pumping station is now a Grade II listed museum as it is the only surviving station in the country that still houses a functioning engine. (Historic England Archive)

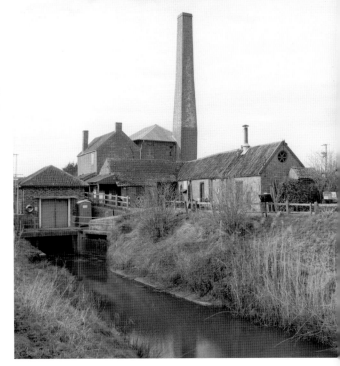

Yeovil Town Railway Station
Like all towns with industry to support, an up-to-date railway station was essential in the late nineteenth and early twentieth centuries, and Yeovil was no different. Yeovil Town railway station was developed rapidly and served the town for over a hundred years – from 1861 to 1967 – before it was demolished. With the town's other railway stations taking prominence, the site had a cinema and leisure complex built on it. (Historic England Archive)

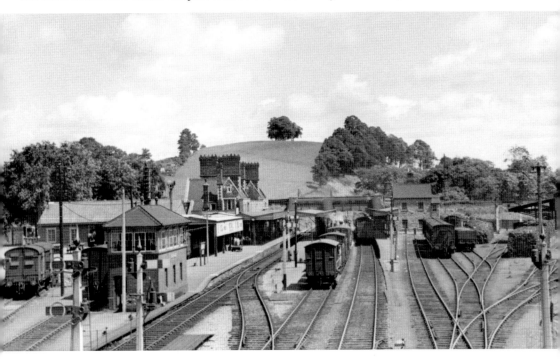

Places of Worship

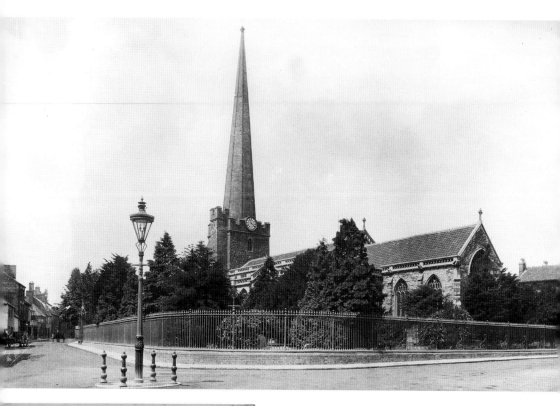

Above: St Mary's Church, Bridgwater
Built in the thirteenth century, St Mary's Church in Bridgwater is a Grade I listed building. In 1685, James Scott, the Duke of Monmouth, watched from the tower as the Royalist forces of James II assembled prior to the Battle of Sedgemoor. (Historic England Archive)

Left: St Aldhelm and St Eadburgha's Church, Broadway
The Grade I listed Church of St Aldhelm and St Eadburgha dates from the thirteenth century and is in an isolated position away from the village, possibly because of an outbreak of the plague. The top of the old cross in the churchyard is missing, thought to have been knocked off by Cromwell's soldiers. (Historic England Archive)

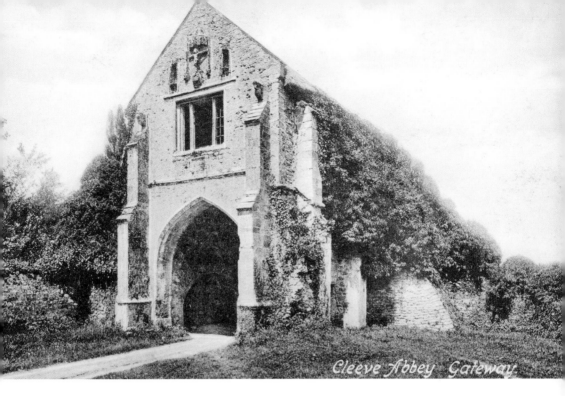

Above and below: Cleeve Abbey

The 800-year-old Grade I listed medieval abbey in the village of Washford is one of the best preserved monastic sites in Britain. Founded as a house for monks in the twelfth century, it was later closed in 1536 by Henry VIII as part of the Dissolution of the Monasteries, and the site was then turned into a rather grand country estate and later into a farm. Built in a valley surrounded by the west Somerset countryside, the peace and tranquillity gives you an idea of why the abbey was built here. As you enter through the impressive gatehouse you get a sense of the size of the place and a feel of what it would have been like hundreds of years ago. The cloister, refectory, dormitory and chapter house all have their own story to tell, through the wonderful architecture on display, various carvings and the impressive heraldic tiled floors. Although the church was destroyed during the dissolution, Cleeve Abbey still retains its spiritual atmosphere. (© Historic England Archive)

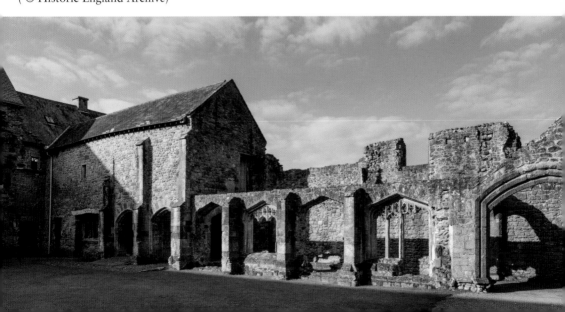

Above left: St Andrew's Church, Cheddar

The Grade I listed St Andrew's Church in Cheddar dates from the fourteenth century and contains the chest tomb of Sir Thomas Cheddar in the chancel. The 100-foot tower dominates the surrounding area and contains a bell from 1759. (Historic England Archive)

Above right: St Mary's Church, East Quantoxhead

St Mary's Church in East Quantoxhead was constructed in the fourteenth century on the site of a pre-existing church. It lies next to Court House and has a close association with the Lutterell family – in particular Sir Hugh Lutterell, whose tomb can be seen in the photograph. He was an important military officer during the Hundred Years War, MP for Somerset and Devon and a close associate of Richard II of England. (Historic England Archive)

Opposite above: Glastonbury Abbey

The Benedictine monastery that stood on the site of Glastonbury Abbey was officially founded in the seventh century. While the foundations of the west end of the nave date to this period, there is a medieval Christian legend that claims Joseph of Arimathea founded the abbey as far back as the first century. The legend says he thrust his staff into the ground, whereupon it took root, leafed out and blossomed as the 'Glastonbury Thorn'. Unusually flowering twice a year, the original Glastonbury Thorn was cut down and burned during the English Civil War by the Roundheads as a relic of superstition. When the Domesday Book was commissioned in 1086, Glastonbury Abbey was listed as the richest in the country, but its fortunes significantly dwindled over the next hundred years with pilgrim visits, a great source of income, falling significantly. Adding to the woes of the monastery, much of the abbey was destroyed by a fire in 1184. (Historic England Archive)

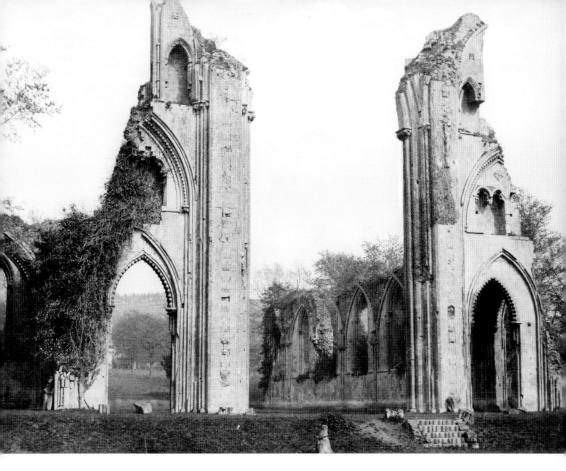

Below: King Arthur's Tomb, Glastonbury Abbey

Rebuilding started almost immediately, and with it came another legend: the discovery of King Arthur and Queen Guinevere's tomb. The majority of historians today cast significant doubt on the authenticity of this, suggesting it was more of a publicity stunt to raise money for the repair of the abbey and place Glastonbury back centre stage on the pilgrimage trail. The legend of King Arthur has been linked with the abbey ever since, along with the possibility that the mystical land of Avalon lay within Somerset. Whatever you believe, visiting the site of King Arthur's supposed resting place is a powerful experience. (© Historic England Archive)

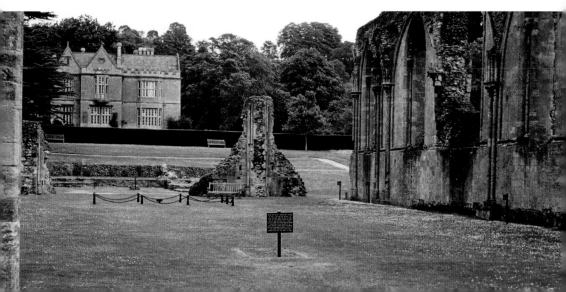

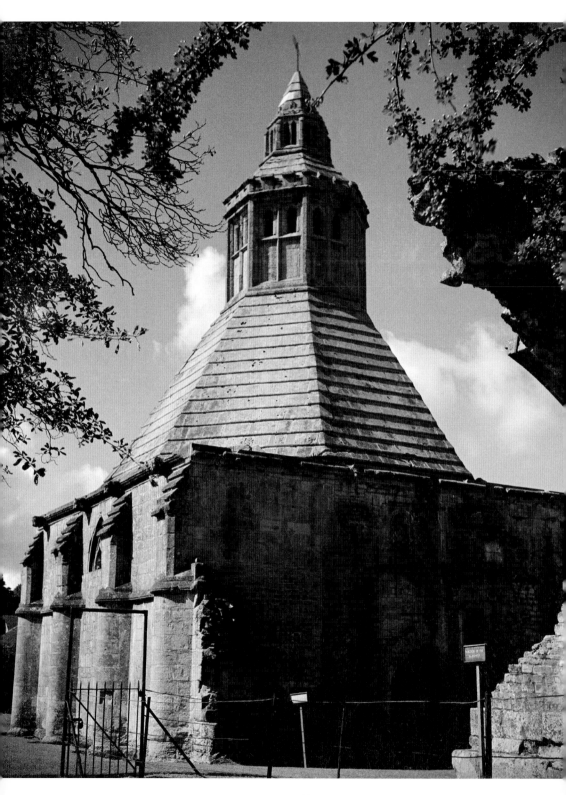

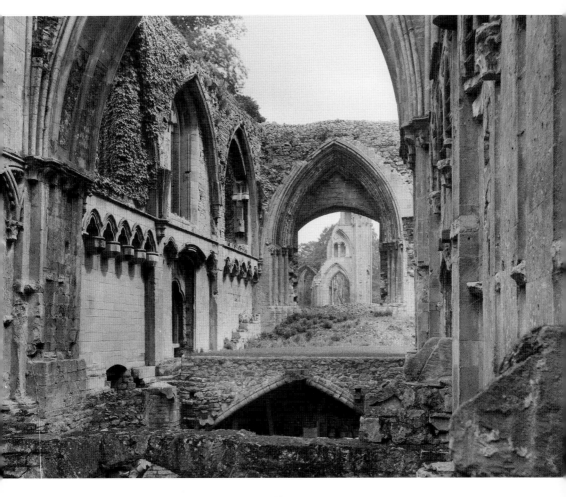

Above and opposite: The Ruins of Glastonbury Abbey

By the fourteenth century the abbey was back to being one of the richest and most powerful monasteries in the country, remaining so until the Dissolution of the Monasteries by Henry VIII. Abbot Richard Whiting was executed on Glastonbury Tor and the abbey was stripped of its valuables, with all the lead and much of the stone being taken and reused for other constructions, leaving the Abbot's Kitchen as the only building to remain intact (see the photograph opposite). Described as 'one of the best-preserved medieval kitchens in Europe', this octagonal kitchen has four massive fireplaces and a vast array of replica artefacts on display, giving you a real sense of what it was like all those years ago. Over 100,000 visitors a year look in awe at the size of the ruins of the great church, each of them trying to imagine what it would have looked like in its complete form. At over 60 metres long and 14 metres wide it is absolutely huge! As shown in the photograph above, taken in 1929, the Lady Chapel, with its two levels, gives a glimpse of what it would have been like inside this vast building and the stone footprints of other buildings on site add the understanding of just how important Glastonbury Abbey was. As well as the ruins, there is an informative visitors centre, which offers schoolchildren in particular great opportunities to extend their learning, including dressing up as a monk! Beyond the remnants of the abbey there are ponds, wildlife and plenty of quiet space to contemplate within the 36 acres of parkland that you are able to enjoy. The history, legends and sheer size of Glastonbury Abbey make this an incredible place to visit. (© Historic England Archive; Historic England Archive)

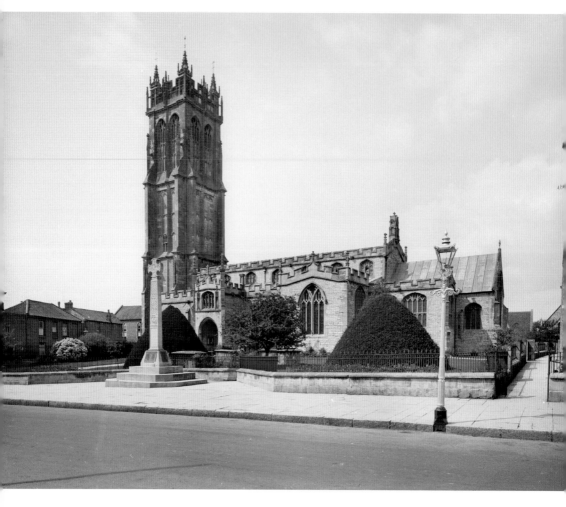

Above: St John the Baptist's Church, Glastonbury

Described as 'one of the most ambitious parish churches in Somerset', the current fifteenth-century building of St John the Baptist's Church in Glastonbury can trace its foundations to Saxon times. In the churchyard is a thorn tree grown from a cutting from the famous Glastonbury Thorn and, following tradition, a blossom from this tree is sent to the Queen every Christmas. (Historic England Archive)

Opposite below: Muchelney Abbey

The small village of Muchelney has the ruined walls and foundations of a medieval Benedictine abbey. The monks originally established the abbey at some point in the tenth century. At the time of Domesday they paid a tax of 6,000 eels a year caught from the local rivers and streams. By the twelfth century the abbey was very profitable and the majority of the building work was carried out then. By 1308 they had built 'The Priest's House' on nearby land, and this building is still standing in the village today. In the sixteenth century a large abbey church was constructed, along with the abbot's house, which is shown in this reconstruction of Muchelney Abbey as it may have appeared around 1500. (© Historic England Archive)

St John the Evangelist's Church, Milborne Port
A view of the front of St John the Evangelist's Church in Milborne Port, before its 1867 restoration. The church dates back to Anglo-Saxon times and as a result is designated as a Grade I listed building, due to its origins before the Norman Conquest. (Historic England Archive)

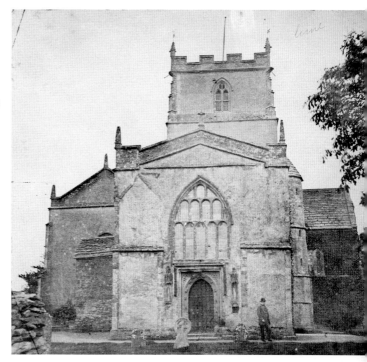

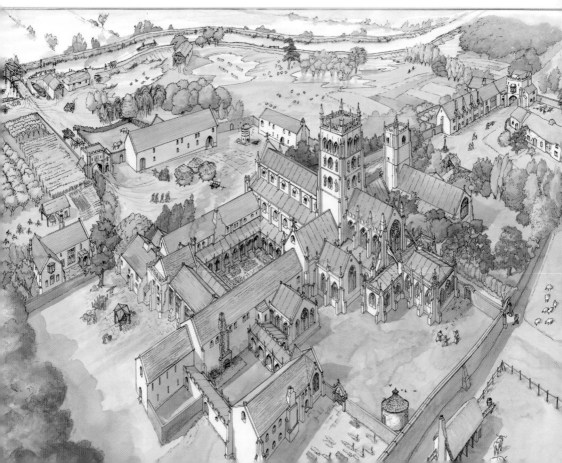

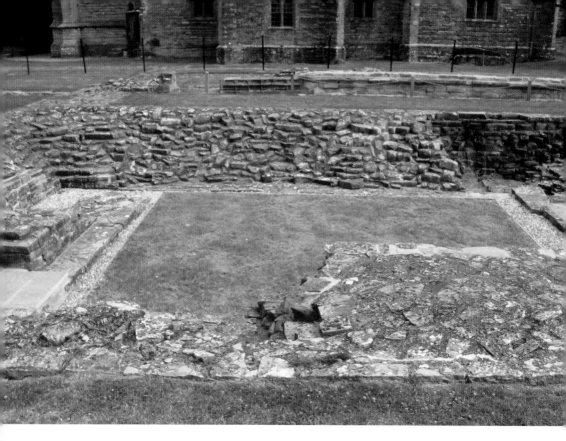

Above: Muchelney Abbey

In 1538, everything was surrendered by the monks to Henry VIII as part of the Dissolution of the Monasteries. All the buildings were destroyed, with stone from the site being recycled and reused in many local buildings. Aside from some decorative floor tiles, which were relaid in the nearby Church of St Peter and St Paul, all that remained was the abbot's house, and this is the stand out feature of a visit today. The site is set within green rolling hills and the stone foundations on the floor give you a tantalising glimpse of what would have been an impressive abbey complex. The abbey building itself was over 50 metres long, with only Glastonbury Abbey being longer in the county, and there are stone footprints of a range of other structures. The abbot's house is well preserved with a great chamber inside that has a rather ornate fireplace, a carved wooden settle (seat) and stained glass. There are even wall paintings that are easily visible and show a snapshot of abbey life back in the sixteenth century. (© Historic England Archive)

Opposite above: St Thomas à Becket Church, Pylle

The Grade II listed church in Pylle was built in the fifteenth century, but only the tower remains from this time, with the rest of the church (shown here) being rebuilt in 1868. (Historic England Archive)

Opposite below: Wells Cathedral

Central to the city of Wells is a walled precinct known as the Liberty of St Andrew, which contains a number of buildings all constructed around 1450, most significant of which is the twelfth-century cathedral. The seat of the Bishop of Bath and Wells, the medieval building stands proudly as the centrepiece of the city. At over 50 metres in height, it dwarfs everything else nearby and its Gothic architecture and symmetry draws your eyes in. (© Historic England Archive)

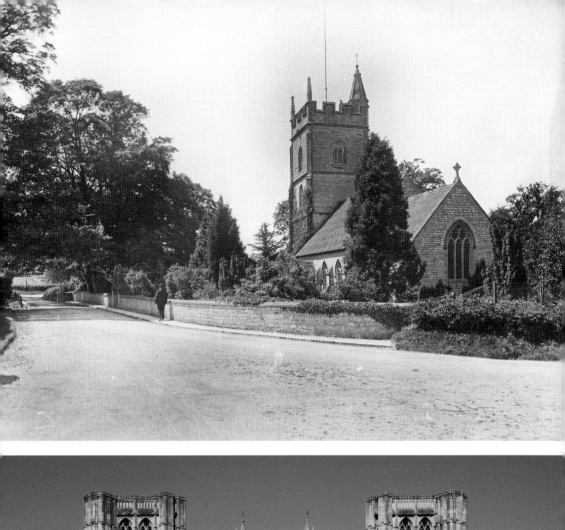
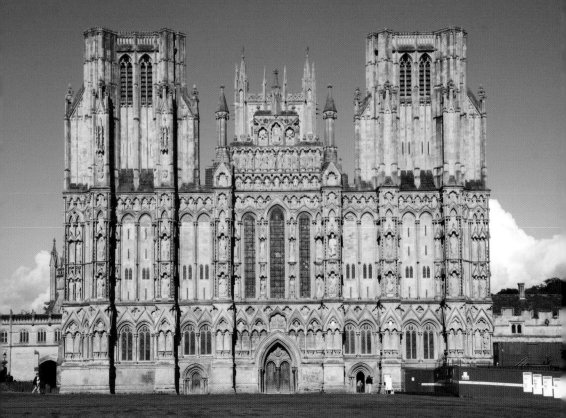

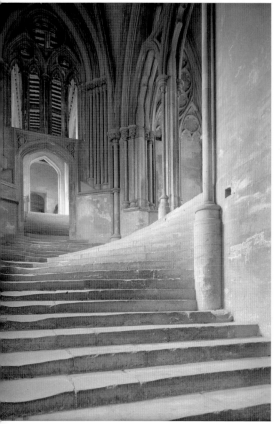 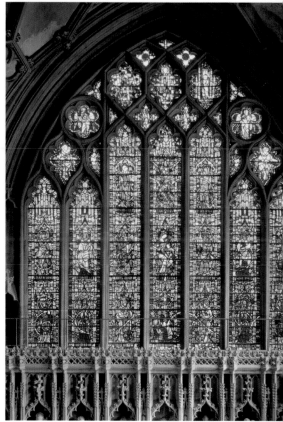

Above left and right: Interior of Wells Cathedral

The inside of Wells Cathedral is equally as impressive and worth visiting. The cloisters, choir stalls and nave are set out impressively, but this cathedral holds other beautiful secrets too. The octagonal chapter house holds fifty-one decorated stalls set beneath windows and an impressive fan-vaulted ceiling, all of which are reached via some delightful stairs (above left) known as the 'Sea of Steps', which are visibly worn down due to the impact of centuries of people visiting. The Lady Chapel, with its stunning stained-glass windows (pictured here is the Great East Window) and stellar vault, is reached through the retrochoir, which, with its multitude of angled piers supporting the roof, is itself something to behold. The cathedral clock is also worth a mention as it is famous for its twenty-four-hour astronomical dial and a set of jousting knights that perform every fifteen minutes. (Historic England Archive; © Crown copyright. Historic England Archive)

Entertainment and Leisure

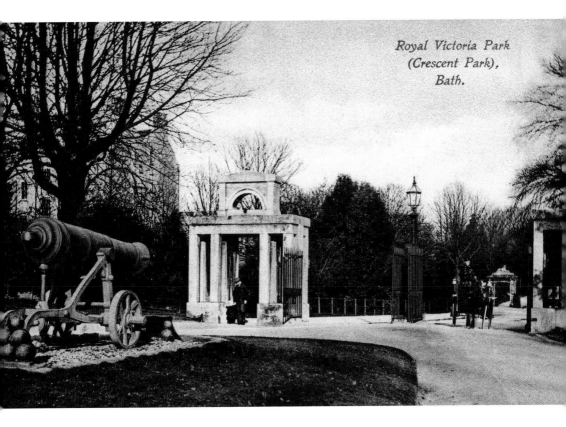

Royal Victoria Park (Crescent Park), Bath.

Royal Victoria Park, Bath
This park was opened in 1830 by the eleven-year-old Princess Victoria, seven years before she became queen, and was privately run until 1921 when the Bath Corporation took over. Overlooked by the Royal Crescent, there are 57 acres of space for people to enjoy, with golf courses, tennis courts, bowling and skateboarding to entertain people, along with a large 9-acre botanical garden. The gates seen in this image were removed as part of the Second World War national scrap metal campaign. (Historic England Archive)

Parade Gardens, Bath
To the south-west of the River Avon is the delightful 2-acre site of the Grade II listed Parade Gardens. Laid out in 1709 and originally called St James's Park, the gardens offer wonderful views of Pulteney Bridge and provide an escape in the very heart of the city. The bandstand is still used to this day and the bedding displays are said to be among the best in the country. (Historic England Archive)

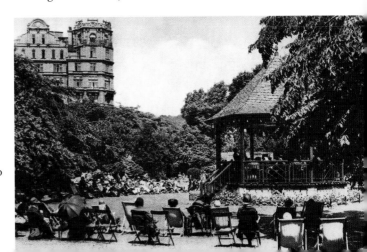

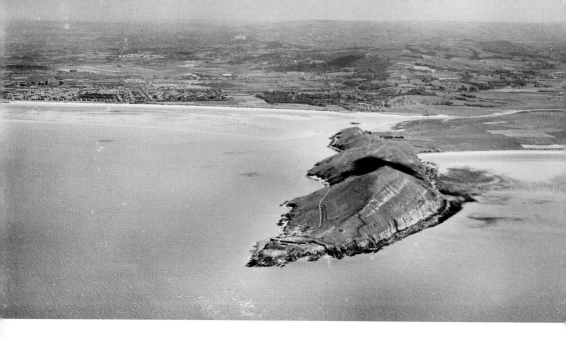

Above: Brean Down

Brean Down is a natural outcrop of land that has to be one of Somerset's most stunning vistas. You can either head to the vast expanse of beach for some relaxation or prepare yourself for the 200 or more steps up to sample the spectacular panorama from the headland. Humans have used this location for a long time; there is evidence of a permanent Iron Age settlement. (© Historic England Archive. Aerofilms Collection)

Below: Brent Knoll

Brent Knoll is an Iron Age hill fort over 100 metres high that has had human settlements on it since before 2000 BC. Well over a hectare in size, it has a single ditch around it as well as a range of ramparts. Located to the south of Burnham-on-Sea and looked after by the National Trust, it dwarfs the landscape surrounding it and is easily visible from the M5. There is evidence that the Romans used the site: coins, roof tiles and painted wall plaster have all been found, and these items are on display at museums in Taunton, Bridgwater and Weston-super-Mare. The Romans called it the Mount of Frogs as, at the time, it was an island surrounded by marshland before the Somerset Levels were drained. The knoll is also thought to be the site of the 875 battle between the Anglo-Saxon kingdom of Wessex and the Great Viking (Heathen) Army. Due to its elevated state, it is no surprise that Brent Knoll was used during the Second World War as an anti-aircraft gun emplacement, and today it is a popular destination for ramblers. (Author's collection)

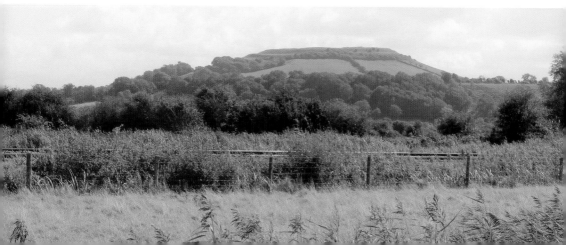

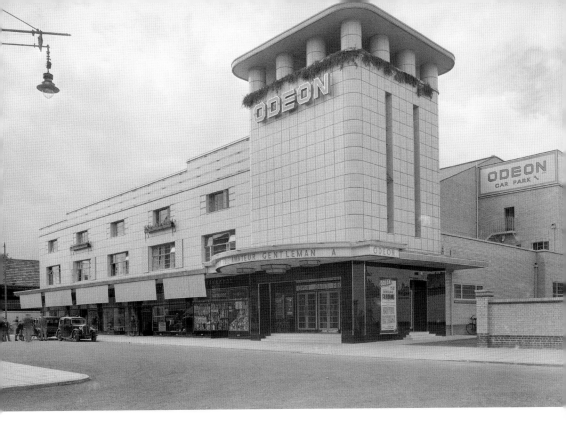

Odeon Cinema, Bridgwater
The former Odeon cinema on Penel Orlieu in Bridgwater, Somerset, was designed by British architect Thomas Cecil Howitt. It featured a square tower with a flat slab roof that was supported by columns, while a curved canopy projected outwards above three sets of double doors providing access to the street via steps into the foyer. There is still a cinema on the same site, although now different in design. (Historic England Archive)

Burnham-on-Sea
Holidaymakers on the beach and Esplanade at Burnham-on-Sea at the end of the nineteenth century. Thanks to the development of the railways, Burnham-on-Sea became a tourist hotspot for the Victorians. (Historic England Archive)

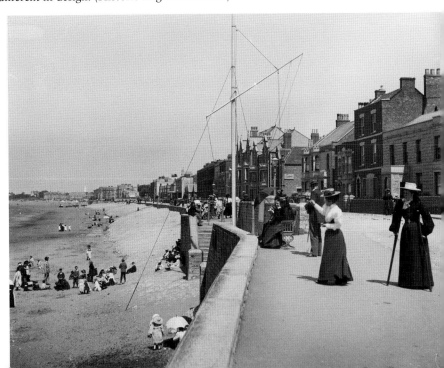

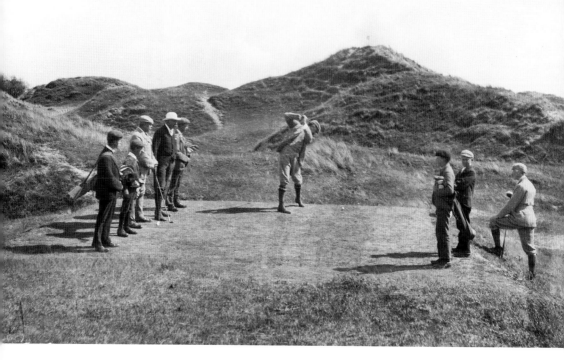

Above: Burnham and Berrow Golf Course

Burnham Golf Course was originally opened as a nine-hole layout, and in this photograph golfers and caddies from the London Midland & Scottish Railway on a day trip to the seaside are stood watching a colleague drive a shot. In 1910, the club was extended to an eighteen-hole layout. (Historic England Archive)

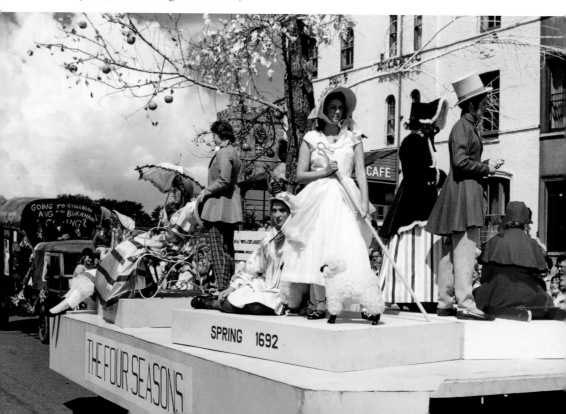

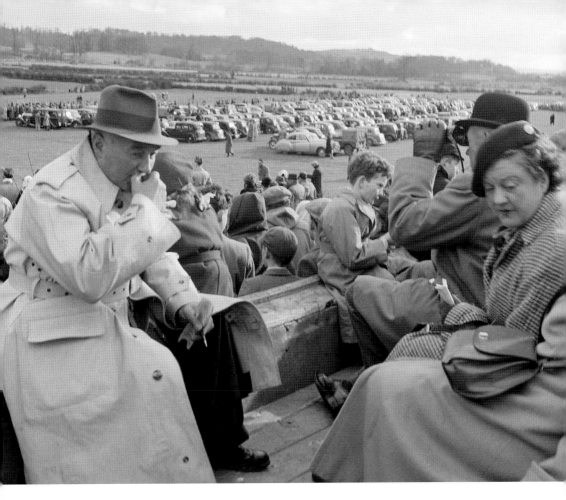

Above: Horse Racing, Charlton Horethorne

Horse racing, known as the 'sport of kings' due to its popularity with aristocrats and royalty, has been a favourite past-time for many over the years. This photograph, taken in the 1950s, shows people seated outside the boundary fence for the Blackmore Vale meet at Charlton Horethorne. (© Historic England Archive)

Opposite *below*: Carnival Season, Burnham-on-Sea

Somerset is famous for its carnivals, which date from the 1605 carnival in Bridgwater where a celebration was held on 5 November following the failure of the plot involving Guy Fawkes to blow up the Houses of Parliament, and takes place from August to November each year. The Burnham-on-Sea Summer Carnival began in the early twentieth century and was held on the August bank holiday Monday, as seen in this picture. The last Summer Carnival was held in 1965 and since then, Burnham-on-Sea carnival joined with Highbridge as a winter carnival. (© Historic England Archive)

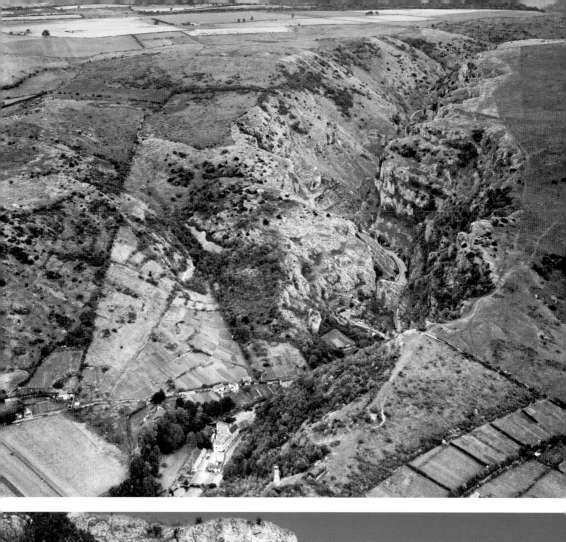
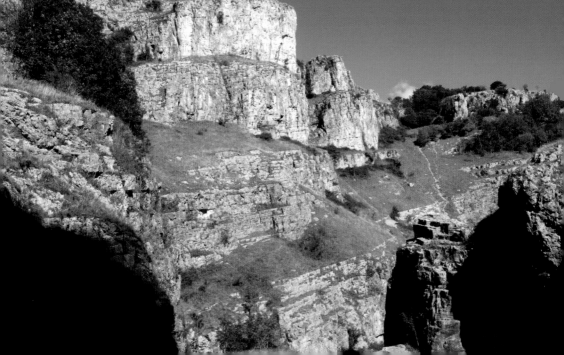

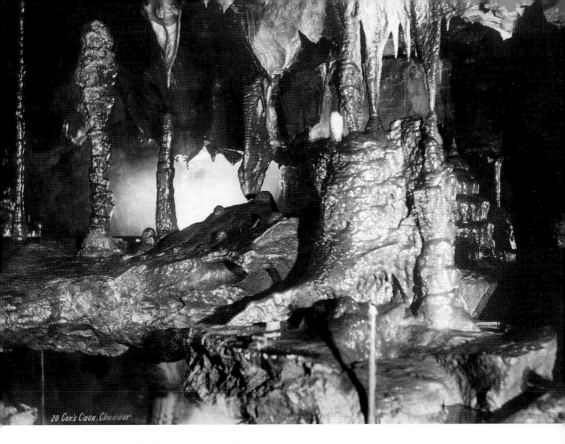

20 Cox's Cave. Cheddar

Above and opposite: Cheddar Gorge and Caves
Lying at the edge of the Mendip Hills, Cheddar Gorge is a spectacular site that has been thousands of years in the making. The near-vertical cliffs cut 130 metres down into the limestone and have provided breathtaking views for tourists for centuries. In the aerial view, taken in 1946, you can make out the watchtower, which still stands at the top of the 274-step 'Jacob's Ladder' route to the clifftops, while the colour photograph shows the magnificence of this natural wonder from ground level. The caves at Cheddar, excavated in the late nineteenth century for Victorian exploration and tourism, have drawn in visitors with the amazing rock formations as well as great stalagmites and stalactites that they offer, as shown in this photograph of Cox's Cave taken at the turn of the century. (© Historic England Archive. Aerofilms Collection; © Historic England Archive; Historic England Archive)

Gymkhana, Creech
St Michael
An action shot of a
wheelbarrow race at a
Gymkhana in Creech
St Michael in the 1950s.
Events like this were
commonplace across
the county during
the summer months.
I wonder if they won?
(© Historic England Archive)

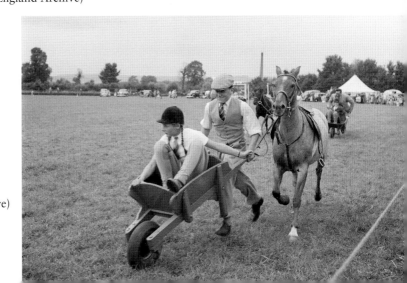

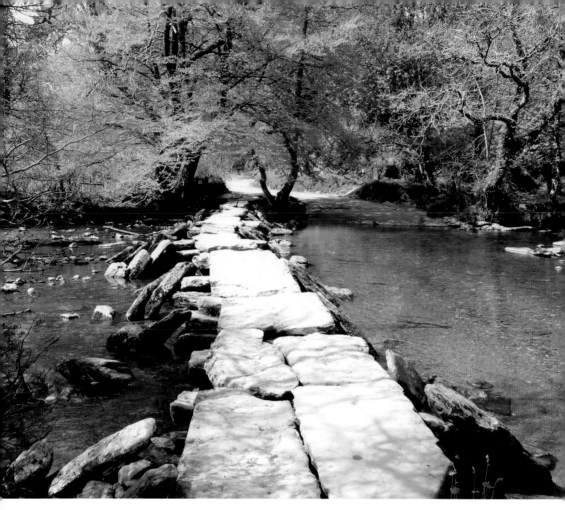

Above and left: Exmoor
The unspoilt beauty of the 267 square miles of Exmoor National Park has been enjoyed by thousands over the centuries. The variety of landscapes and vistas can be breathtaking, from cliffs plunging into the Bristol Channel, miles and miles of remote moorland and vast woodland areas offering something for everyone. The photograph above shows Tarr Steps, a seventeen-span clapper bridge that is over 50 metres in length, while the photograph to the right shows a scene from an equestrian-related fair held on Exmoor sometime between 1950 and 1965, showing men resetting skittles on a makeshift alley ready for the next game, with a view over the moor in the distance. (Author's collection; © Historic England Archive)

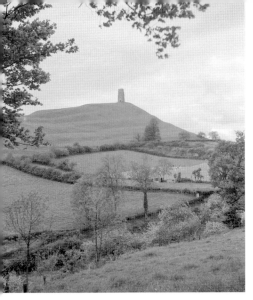
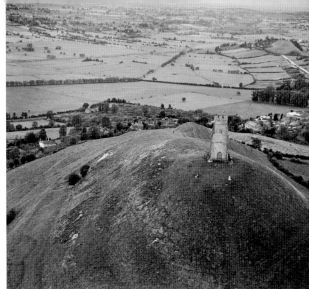

Above left and right: Glastonbury Tor

One of Somerset's most famous draws is Glastonbury Tor. As seen in the left-hand image, Glastonbury Tor is clearly visible for miles around as it rises up 500 metres from the Somerset Levels (note the cricket match taking place in the fields below). It has been a part of Celtic mythology, particularly those legends that include King Arthur for centuries, and is certainly a mystical place. There is evidence of buildings being present at the summit during the Saxon period and atop the tor now sits the roofless St Michael's Tower, seen in aerial photograph (right) from 1946. This is all that remains of a fourteenth-century stone church that was demolished by Henry VIII during the Dissolution of the Monasteries and was also the place of execution of the last abbot of Glastonbury Abbey, Richard Whiting. This church was built in the place of an earlier wooden church that was destroyed by an earthquake in 1275. With two pathways up, one significantly steeper than the other, it is a brisk walk up to the top that catches even the seasoned walker out of breath as their pace quickens when in sight of the summit. It is all worth it though for the view, which on a clear day stretches for miles around in every direction. (© Historic England Archive; © Historic England Archive. Aerofilms Collection)

Kilve Beach

Kilve beach is a designated SSSI (Site of Special Scientific Interest) thanks to the cliffs, which are formed by oil-rich layers of rock and often contain fossils. The way in which the wind and waves have cut the rock is mesmerising, and over the centuries young and old alike have studied the different layers of rock that have been exposed. Then, of course, there is the prospect of finding fossils! The dinosaur hunter in all of us has the chance to explore the miles and miles of coastline in search of the remnants of these creatures, and there are some impressive large fossils visible. (Author's collection)

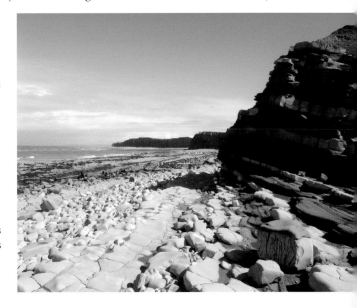

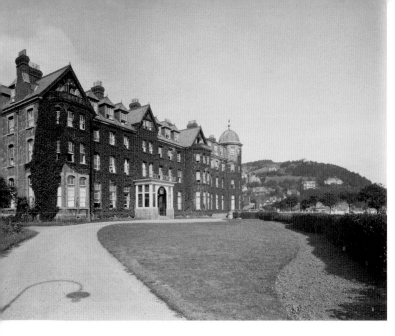

Metropole Hotel, Minehead
The four-storey Metropole Hotel was built in a prominent position in 1892 on the Esplanade in Minehead. It had sixty bedrooms and was used by Indian rajahs when they played polo at Dunster – their ponies were exercised on the beach below the hotel. The building still exists, but has been converted into apartments. (Historic England Archive)

Collett Park, Shepton Mallet
John Kyte Collett opened this public park on 20 June 1906. It is believed that as a young boy John Collett was forcibly removed from a private park and he vowed to provide a facility that all children could use. To this day Collett Park is still well used by the local community, with an annual three-day festival in the summer, and concerts and other special events are held all year round. (Historic England Archive)

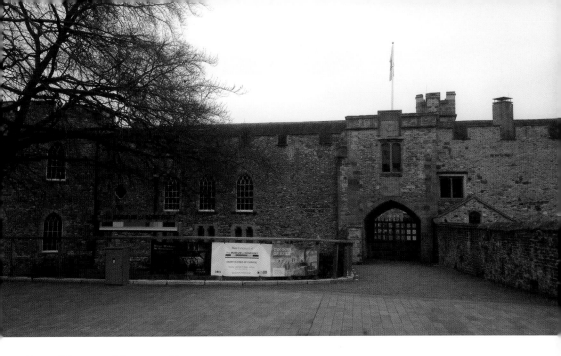

Above: Museum of Somerset, Taunton
The Museum of Somerset and the Somerset Military Museum contain a large range of artefacts from across the county from many different eras. The location itself is full of historical significance, being on the remains of Taunton Castle, which in its day was very important. The castle was the subject of three blockades during the First English Civil War, 1644–45, known as the Sieges of Taunton, where the castle swapped hands between the Royalists and the Parliamentarians. (Author's collection)

Below: Vivary Park, Taunton
In 1894 the municipal borough of Taunton purchased Vivary Park from the Kingslake family for £3,659 in an effort to encourage healthier lifestyles and provide recreational opportunities for the working class, as set out in the Public Health Act of 1875. Little has changed in its design since it was first laid out in 1895 and the bandstand still remains over 100 years later. (Historic England Archive)

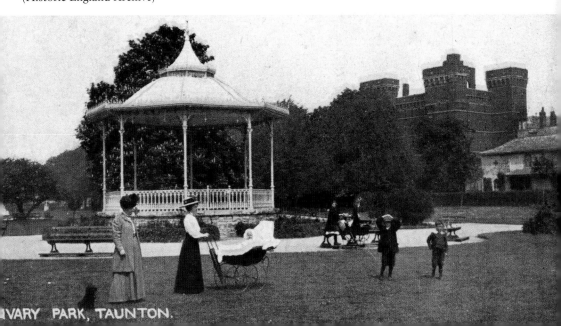

VARY PARK, TAUNTON.

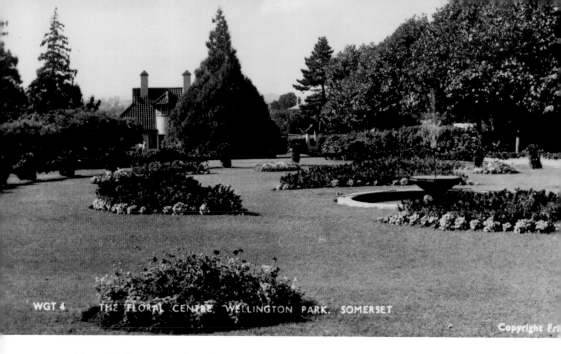

WGT 4 THE FLORAL CENTRE, WELLINGTON PARK, SOMERSET

Copyright Fri

Above: Wellington Park, Wellington

Wellington Park is a Grade II listed formal Edwardian park that is nearly 2 hectares in size. It originally had a bandstand, an ornamental pond and vast floral bedding displays, the floral centre being the subject of the photograph here. The park has been maintained in recent years with help from National Lottery funding, and now includes children's play areas and a skateboard ramp. (Historic England Archive)

Below: The Grand Pier, Weston-super-Mare

Opening in 1904, the 350-metre-long Grand Pier had an impressive 2,000-seat theatre at the end, which was lost to fire in 1930 and was subsequently replaced with an undercover funfair. Again ravaged by fire in 2008, it was reopened in 2010 and remains a constant draw for tourists. (© Historic England Archive. Aerofilms Collection)

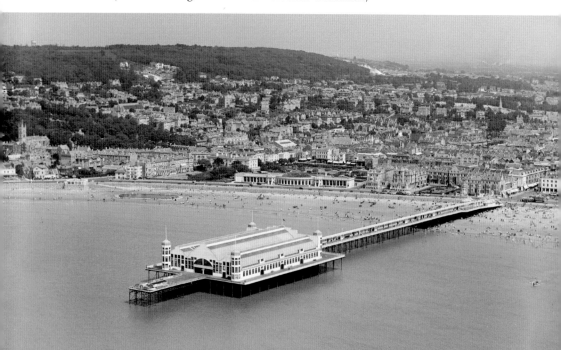

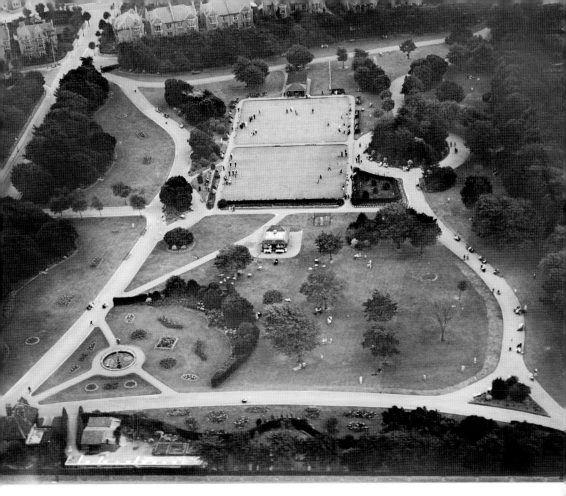

Above: Clarence Park, Weston-super-Mare
Clarence Park was given to the town of
Weston-super-Mare by Rebecca Davies in
memory of her husband and was laid out
with mature trees, flower beds, lawned areas,
fountains and bowling greens, which are still
there today. (© Historic England Archive.
Aerofilms Collection)

Right: The Lido, Weston-super-Mare
A view across the 950-square-metre swimming
pool towards the diving boards shortly after
completion of the Lido. At the time this was
the highest diving board and largest open-air
swimming pool in Europe. In 1982, the
concrete diving boards were demolished and
the Lido became the present-day Tropicana.
(Historic England Archive)

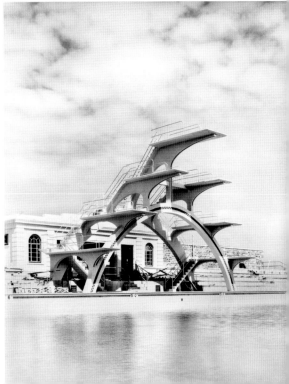

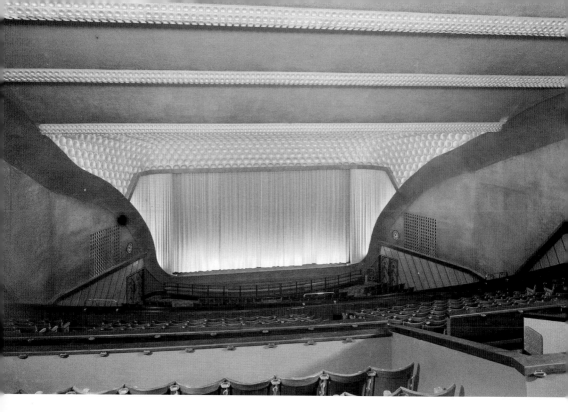

Above: Odeon Cinema, Yeovil
A view of the auditorium of the newly opened Odeon cinema on Court Ash Terrace. The art deco design of this state-of-the-art cinema wowed up to 1,500 people at a time and was eventually closed in 2001. (Historic England Archive)

Below: Sidney Gardens, Yeovil
Sidney Gardens were presented to the town of Yeovil by Alderman Sidney Watts when he was mayor to commemorate the 1897 diamond jubilee of Queen Victoria. Named after himself, they officially opened in 1898. This photographic postcard is from the years immediately after opening, offering locals some pleasant surrounding in which to relax. (Historic England Archive)

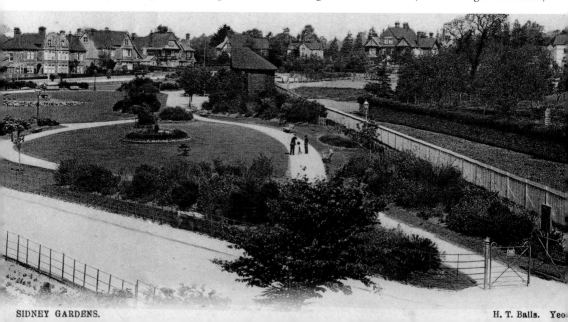

SIDNEY GARDENS. H. T. Balls. Yeo

Country Houses and Estates

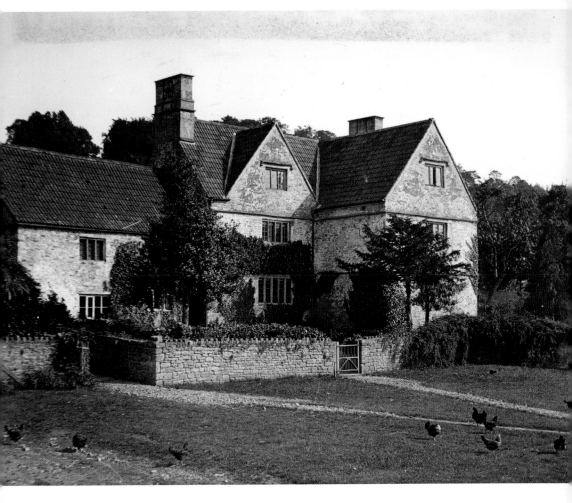

Backwell Court Farmhouse
Somerset is well known for its farmland and a number of impressive farmhouses have been built over the years by the owners of the land. One such example is here in Backwell, where this Grade II listed building is still standing today. (Historic England Archive)

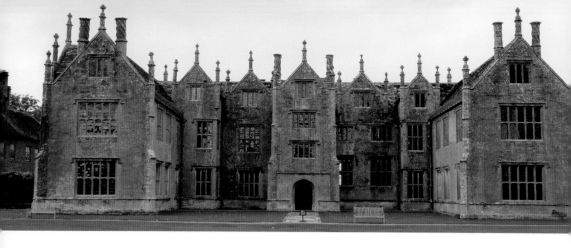

Above: Barrington Court

Barrington Court is a rather grand Tudor manor house near Ilminster. Originally built in the 1550s, it has been owned, inherited and sold many times over the course of its history, falling into a state of disrepair and neglect by 1745. In the 1920s Colonel Abram Lyle (of Tate & Lyle fame) renovated the house with his own personal fortune, and this is the house and gardens that are now open to the public. (Author's collection)

Below: Barrow Court, Barrow Gurney

Barrow Court has had an interesting and varied existence. This site at Barrow Gurney was originally founded in 1212 as a Benedictine nunnery, becoming a private mansion in 1536 after the Dissolution of the Monasteries. The next 300 years saw different owners, until it became the property of the Gibbs family, who significantly renovated the house and gardens in 1890. There are 15 acres of formal gardens, including these steps leading to an archway to the area known as the Twelve Months of the Year, which was built at this time. During the Second World War the house was used as a military hospital by the Allied forces. (Historic England Archive)

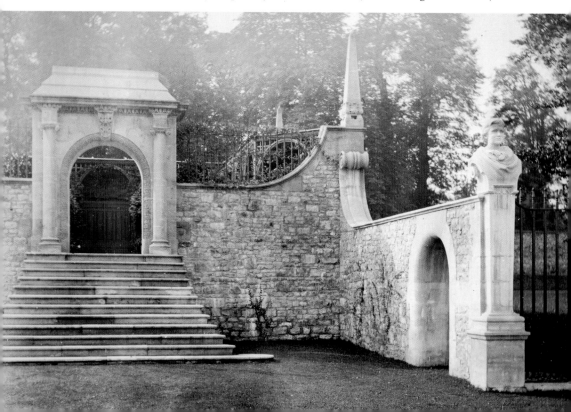

Brympton House, Brympton

Brympton House, also known as Brympton d'Evercy, was built by the d'Evercy family around the year 1220. Little actually remains of the original manor house as the present house evolved over the years on the same site, with each family who owned it adding to the existing structures. The photograph shows the garden terrace on the south side of the house. Today it is still privately owned, although it can be hired for weddings and corporate events. (Historic England Archive)

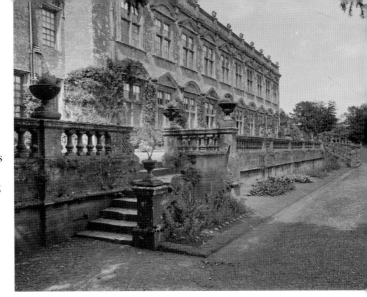

Seymour Court, Beckington

Built in the fifteenth century, Seymour Court is a Grade I listed building that was the home of Thomas Seymour, 1st Baron Seymour of Sudeley, who married Queen Catherine Parr. She was the sixth wife of Henry VIII and married Thomas Seymour just six months after Henry's death. (Historic England Archive)

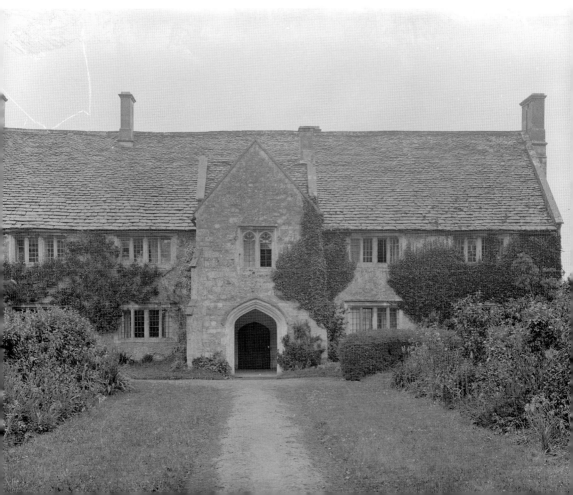

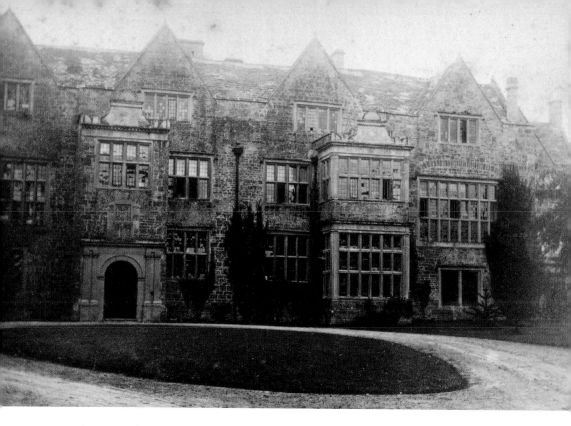

Above: North Cadbury Manor House
North Cadbury Court has a history dating back 700 years to 1300 when it was a medieval hall built by the de Moels. It has been bought, sold and improved many times over the centuries and remains the centre of the farming estate. (Historic England Archive)

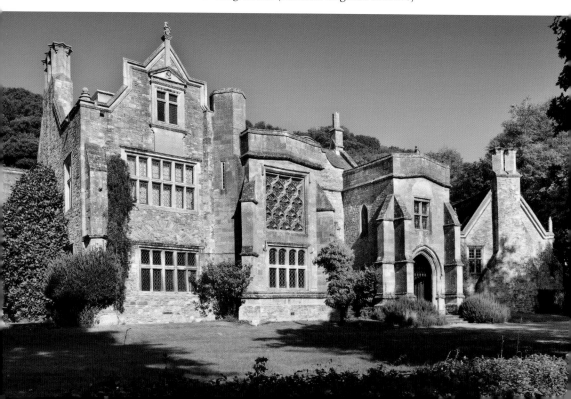

Above and opposite below: Clevedon Court
Clevedon Court, now a Grade I listed building, was constructed in the early fourteenth century by Sir John de Clevedon. In 1709 the prominent Elton family from Bristol purchased the property and they are still resident in the house now, although it is owed by the National Trust. The great hall and chapel are the oldest parts of the building, with the west wing being added in 1570 and further construction occurring in the eighteenth century. The gardens themselves are listed Grade II on the National Register of Historic Parks and Gardens, and feature an octagonal summerhouse at the west end of the garden terrace to the north of the property. (© Historic England Archive; Historic England Archive)

Right: Beacon Tower, Cothelstone
A rare photograph of the stone beacon on top of Cothelstone Hill, Cothelstone. It is believed to have been built sometime between 1768 and 1780 as a folly for Lady Hillsborough, who owned the Cothelstone estate during this period. Built out of rubble stone, it once stood at 9 metres high, but was destroyed around 1919 and today all that remains are some pieces of stone on a mound. (Historic England Archive)

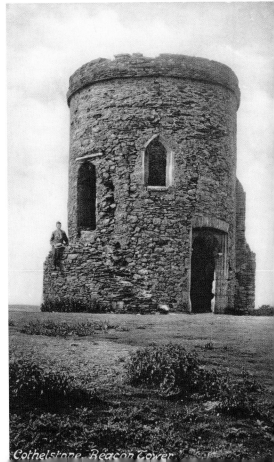

Cothelstone Beacon Tower

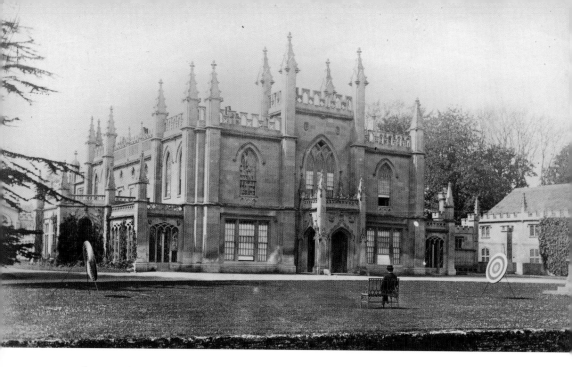

Above: Farleigh House

The Grade II listed Farleigh House is a large country house that was formerly the centre of the Farleigh Hungerford estate. Much of the stone to build it during the eighteenth and nineteenth centuries came from the nearby Farleigh Hungerford Castle. In 1806, Colonel John Houlton inherited the estate and he enlarged and altered the house in the fashionable Gothic Revival style, which is what remains today. In recent years it has been used as a school and is currently the headquarters and training centre for Bath Rugby Club. (Historic England Archive)

Below: Hestercombe House

The La Ware family acquired the Hestercombe estate in the fourteenth century and subsequently built the grand house that is still standing today. In the eighteenth century, a Georgian landscape garden was designed and established with ponds, a grand cascade, a Gothic alcove, a Tuscan-style temple and a folly mausoleum, all of which you can still find today hidden within the 100 acres of land. (© Crown copyright. Historic England Archive)

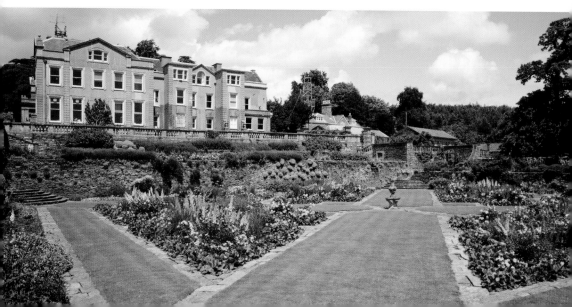

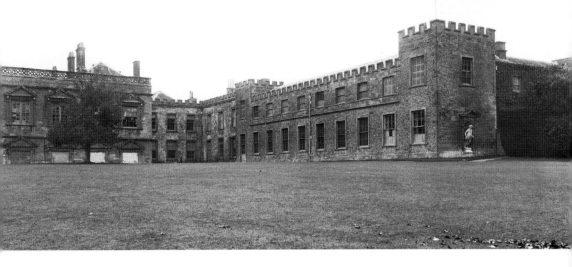

Above: Hinton House

This large country house near Hinton St George was rebuilt around the year 1500 by Sir Amias Paulet, with alterations being made in the following centuries by successive generations. In 1968, the 8th, and last, Lord Poulett sold the house, which was then divided up into flats. (Historic England Archive)

Below: Orchardleigh House, Lullington

The present Orchardleigh House was constructed in 1856 for the Duckworth family, who purchased the estate in 1855. With its own eighteen-hole golf course and island church, it was certainly a Victorian estate of grandeur, which the family held on to until it was sold at the end of the twentieth century. (Historic England Archive)

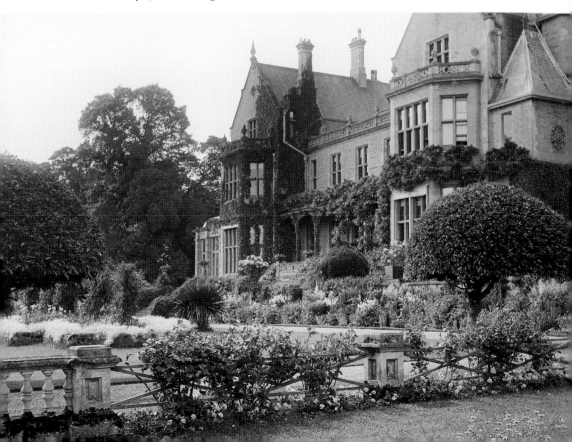

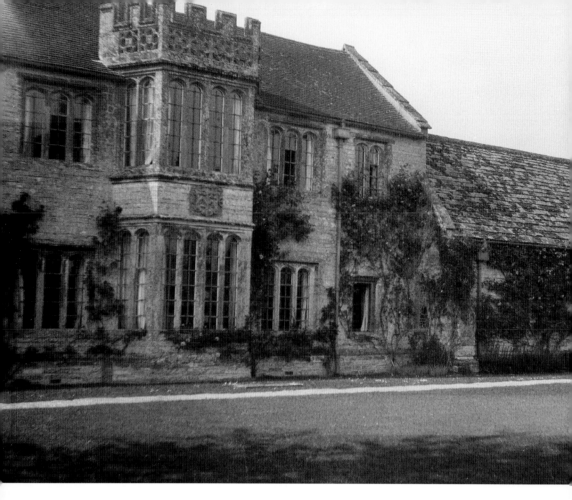

Lytes Cary

The Grade I listed Lytes Cary manor house and formal gardens near Charlton Mackrell takes its name from the Lyte family, who lived here for centuries, and the River Cary, which flows nearby. The Lyte family took over the running of the estate from the late thirteenth century until the mid-eighteenth century, when they sold it in 1755. During this time they continually added new parts to the house, such as a chapel, great hall and oriel room. Following this, the house fell into disrepair, until it was bought by Sir Walter Jenner in 1907 (son of Queen Victoria's physician), who began restoring the manor house to its former glory. (Historic England Archive)

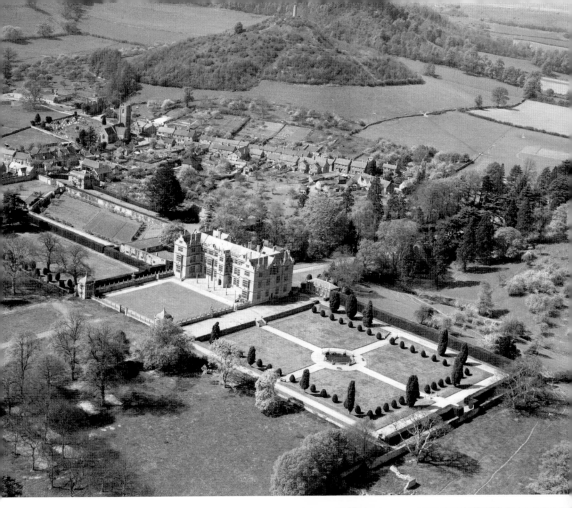

Above and right: Montacute House
Built in 1598 for Sir Edward Phelips, the opening prosecutor during the trial of the Gunpowder Plot, Montacute House is a splendid example of an Elizabethan mansion with some stunning gardens – nearly 10 acres in total. In the aerial view, taken in 1948, you can make out the church and village, while in the background St Michael's Hill is clearly visible. The interior photograph from 1924 shows the grandeur of the long gallery, which at 52 metres in length is the longest surviving example in the country. (© Historic England Archive. Aerofilms Collection; Historic England Archive)

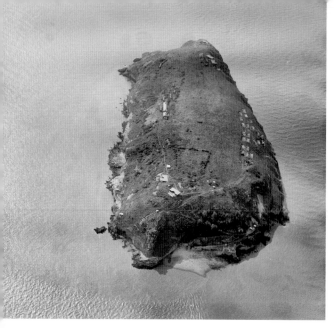

Steep Holm
Located 5 miles out to sea in the Bristol Channel, Steep Holm is a mile-long island that rises up 60 metres and is currently a protected nature reserve and a Site of Special Scientific Interest, owned by the Kenneth Allsop Trust. It is said that the Vikings once sought refuge here in 914 and over the years, this remote outcrop has been the site of an Augustinian priory and, due to its strategic position, a Palmerston Fort was constructed in the 1860s and a coastal battery during the First and Second World Wars. Although difficult to visit, its simplistic beauty offers a haven for wildlife. (© Historic England Archive. Aerofilms Collection)

Glencot House, Wookey Hole
The Grade II listed Glencot House was completed in 1887 as the residence for the Hodgkinson family, who owned the Wookey Hole Paper Mill. In 1904 Gerard William Hodgkinson played first-class cricket for Somerset and was a decorated soldier and airman who saw service in both the First and Second World Wars. The house is now a luxury hotel. (Historic England Archive)

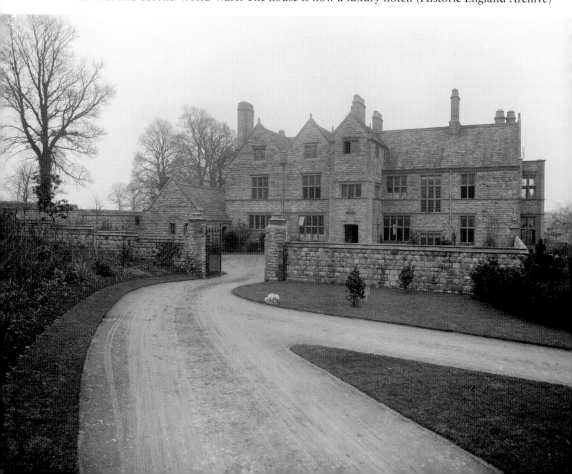

Somerset at War

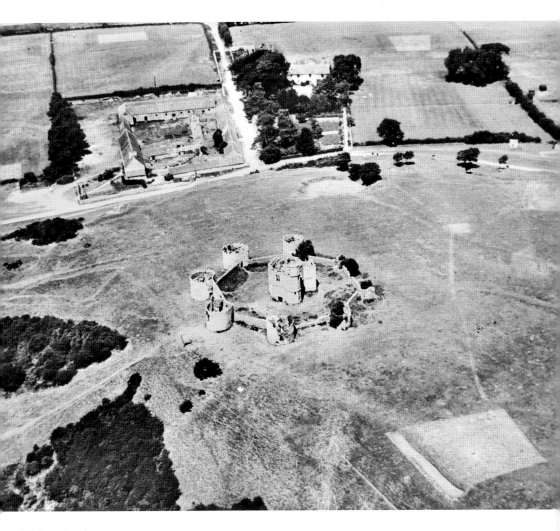

Walton Castle

Set on top of a hill to the north of the town, there is evidence to suggest that Walton Castle was once an Iron Age hill fort. There is mention of it in William the Conqueror's Domesday Book in 1086, where it is recorded as belonging to 'Gunni The Dane', primarily being used as a hunting lodge. The footprint of the castle that is there today was built in 1615–20, but after the English Civil War it lay derelict for nearly 200 years from 1791 to 1979 – evident in this aerial photograph from 1930 where it is possible to spot the crumbling towers and walls. It has since been restored and is now a privately owned Grade II listed building. (© Historic England Archive. Aerofilms Collection)

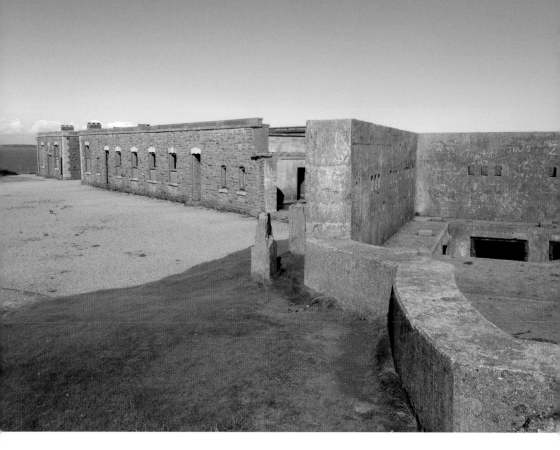

Palmerston Fort, Brean Down
In 1864, a Palmerston Fort was built in response to Queen Victoria's concerns about the strength of the French Navy, and the stunning location of Brean Down helped protect the approaches to both Bristol and Cardiff. The peninsula and its fort were then used again in the Second World War as a coastal battery, again defending the Bristol Channel. (Author's collection)

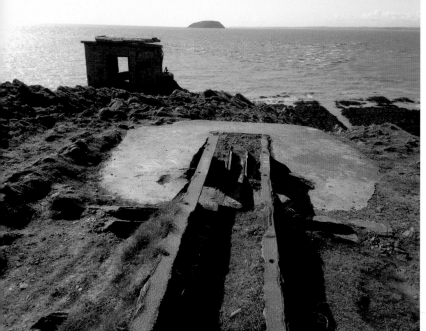

Secret Test Site, Brean Down
During the Second World War, as well as being a coastal battery, the very end of Brean Down was used as a test launch site for experimental weapons and rockets. The launch tracks, which would have been far away from any prying eyes, still remain as a reminder of these times. (Author's collection)

Bridgwater Castle

Mentioned in the Domesday Book due to its standing as a trading centre, in 1200 King John granted a charter to construct Bridgwater Castle, which provided the lord of the manor of Bridgwater, William Brewer, a grand and imposing base with which to expand the town ... and his own wealth! Over the centuries the castle's fortunes waned. Very little remains of this once vast stronghold, save for a small portion of the wall and the water gate, located on West Quay where the arched entranceway provided access into the castle through the east wall for those arriving by boat. (Historic England Archive)

Cadbury Castle

The Bronze and Iron Age hill fort of Cadbury Castle covers 18 acres and still has its terraced defensive earthworks in situ. Located at the top of Cadbury Hill, Cadbury Castle has been excavated a number of times, with artefacts from a number of periods being unearthed. It is thought to have been later used by the Romans as a military barracks and refortified in the Middle Ages. Intriguingly, the site was once known as 'Camalet', with some believing that this is the site of King Arthur's Camelot. Whether it was or not remains to be seen, but people have certainly enjoyed the marvellous views from the top for centuries. (Historic England Archive)

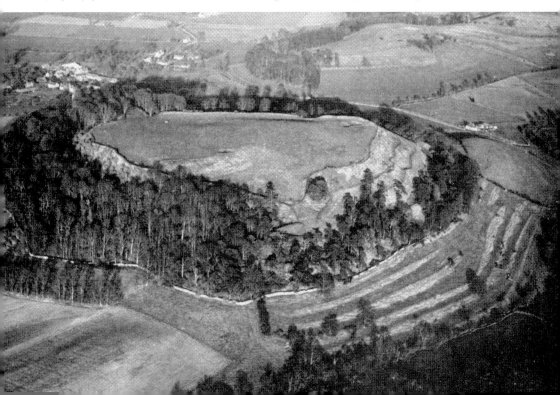

Above: RAF Culmhead

Originally named RAF Church Stanton because of the nearby village of the same name, it began operations in 1941 with three tarmac runways and a number of hangers. Over the next two years Polish and Czech squadrons occupied the airfield, and in 1943 the base was renamed RAF Culmhead, to avoid radio confusion with RAF Church Fenton in Yorkshire. Aircraft continued to participate in operations for the remainder of the war, with No. 131 Squadron flying their Spitfires from Culmhead to Normandy on day one of the D-Day landings. In July 1944, RAF Culmhead became the first base within the Allies to have jet-powered aircraft on site, with arrival of two Gloster Meteor Mk Is. After 1945, the airfield was used for glider and aircraft maintenance training until it was closed in 1946. Today, a number of derelict structures remain, such as the control tower, hangers, fighter pens and the flight office building, shown here in this photograph. (Author's collection)

Opposite: Dunster Castle

During the English Civil War in the 1640s, Dunster Castle switched hands between the Royalists and Parliamentarians a number of times, with Robert Blake leading a Parliamentarian siege of Dunster, staying in control for the next four years before partially destroying some parts of the castle. In the centuries that followed, the upkeep of the castle proved to be very expensive and it saw little by way of military action as it became more of a grand home. Approaching the castle up the cobbled path from the town, you get a sense of how imposing the place would have been – the approach to the entrance sees the walls tower ominously over you. However, once inside you are greeted by a lavish house with all the home comforts anyone could need. From the huge library with more books than you could ever need to the impressive grand staircase and the billiard room, not to mention the countless other rooms, it really is a grand residence. One of the best features is the stunning views across the Bristol Channel you can get from the conservatory, which are replicated from the majority of the windows you look out of and also when you go outside. It is possible to spend hours in the grounds of the castle. The gardens have a whole range of plants and vegetation, cared for in the four different microclimates, and there is an unground reservoir beneath the site of the original keep as well as the rather eerie crypt! (Historic England Archive; Author's collection)

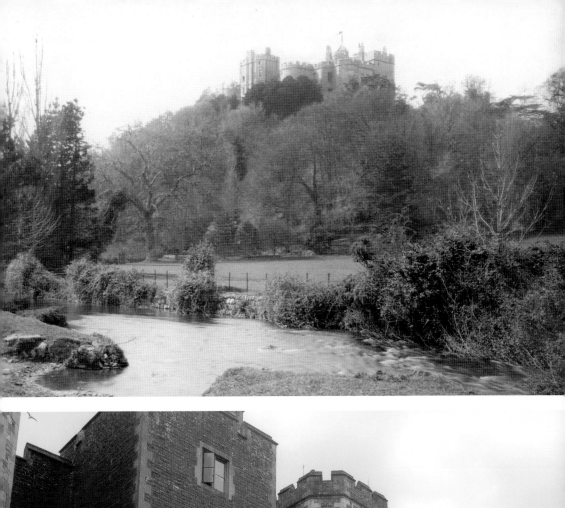

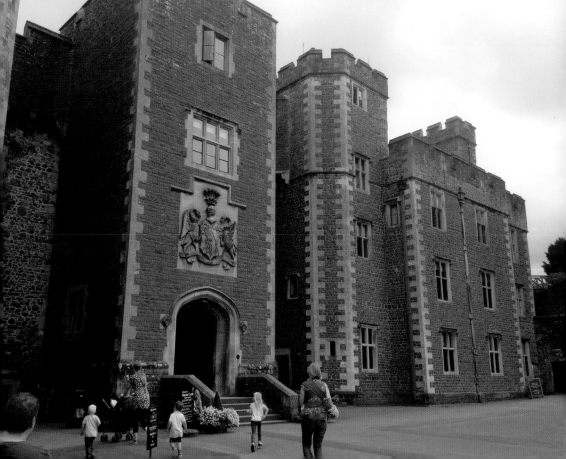

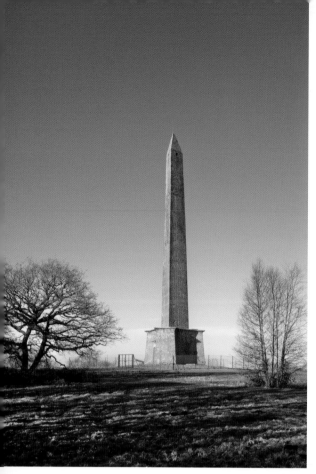

Left: Wellington Monument
Completed in 1854, the Wellington Monument was funded by public subscription to commemorate Arthur Wellesley, 1st Duke of Wellington, who helped defeat Napoleon at the Battle of Waterloo. The 175-foot triangular obelisk is the highest point on the Backdown Hills and the views from the viewing platform, now sadly closed to the public, must have been spectacular. (© Historic England Archive)

Below: Taunton War Memorial
The war memorial in Vivary Park was unveiled and dedicated on 16 March 1922, listing the 449 names of those from the town who had lost their lives in the First World War. Since then a further 162 names were added after the Second World War, and three following the Troubles in Northern Ireland. It stands at the entrance to the park and the beautiful surroundings are a fitting tribute to the fallen. (Historic England Archive)

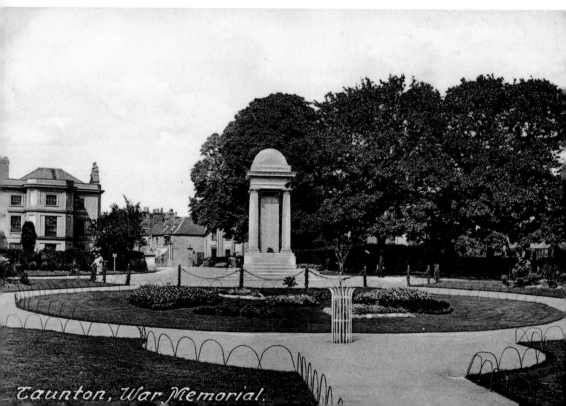

Taunton, War Memorial.

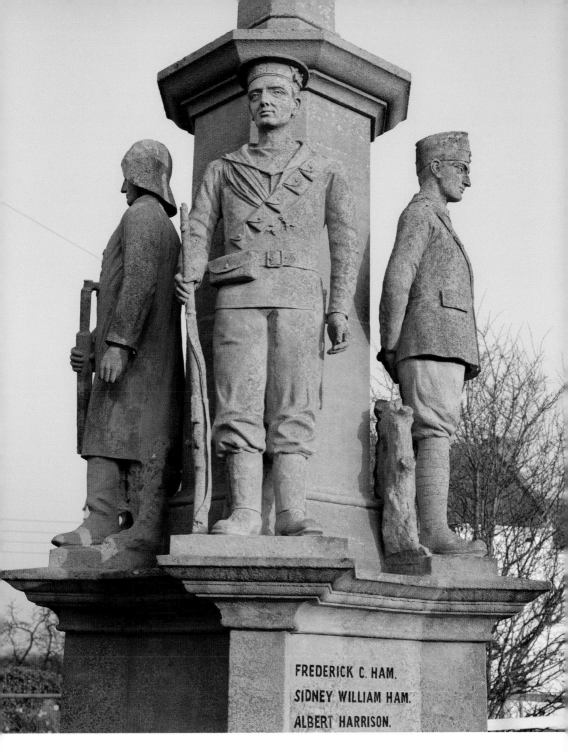

FREDERICK C. HAM.
SIDNEY WILLIAM HAM.
ALBERT HARRISON.

East Brent War Memorial
Dedicated in May 1921, the East Brent War Memorial is striking because of the four
sculpted figures around the plinth of an airman, a sailor, a merchant seaman and a soldier.
There are eighteen names listed from the First and Second World Wars and the Korean War.
(Historic England Archive)

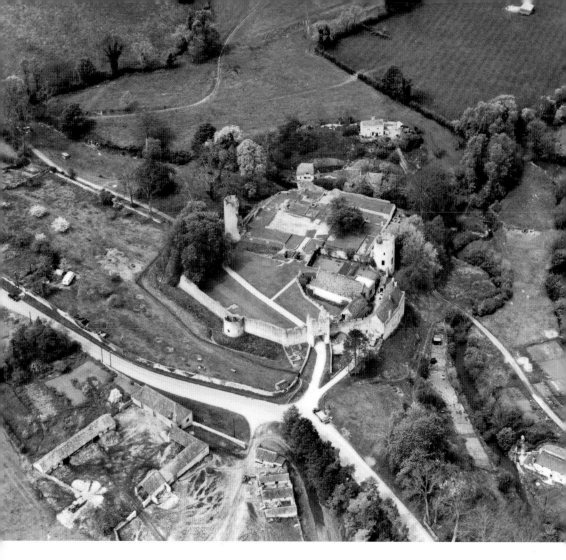

Above and opposite above: Farleigh Hungerford Castle

Right on the border with Wiltshire and sat on a low spur overlooking the River Frome is the vast remains of Farleigh Hungerford Castle. Building of what is now the inner court on the site of a manor house was started in 1377 by Sir Thomas Hungerford, who was the first person to hold the office of Speaker of the House of Commons. His son Sir Walter Hungerford, who fought at Agincourt, extended the castle by constructing an outer court between 1430 and 1445 and the footprint of the bastion, along with a number of buildings that are still standing, are an exciting visit. During the English Civil War, the Hungerford family declared themselves to be Parliamentarians, only to see the castle fall into the hands of the Royalists in 1643. It was retaken by Parliament right at the end of the war in 1645, which meant the castle avoided any slighting – the partial or complete construction of a fortification to make it unusable as a fortress. The castle left the Hungerford family in 1686 and by 1730 it was in a state of disrepair, with much of it being broken up for salvage, and this is what we see today. Inside there are a mixture of well-maintained buildings and the footprints of structures that no longer exist. Two towers dominate the skyline, along with the priest's house and chapel. St Leonard's Chapel, with its wall paintings, stained-glass windows and carved family tombs of the Hungerfords, is still used for local events while there are archaeologically important coffins made of lead in the crypt. (© Historic England Archive. Aerofilms Collection; Historic England Archive)

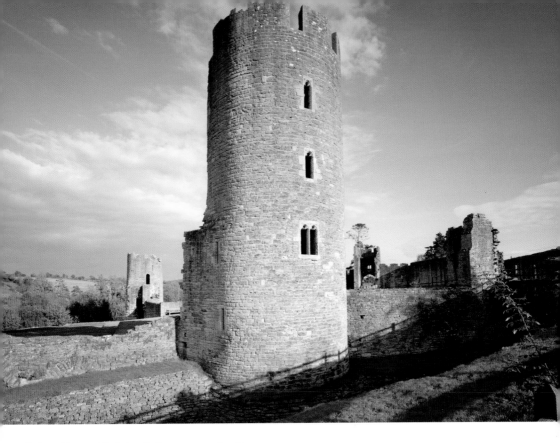

Below: Downside School, Stratton-on-the-Fosse
Cadets from the Downside Officer Training Corps pose for a photograph on the school tennis courts during the interwar years. Formed in 1909, the War Office gave the Downside OTC permission to open a firing range complete with service ammunition in 1912 at the lower end of the cricket field! In 1948, this was renamed the Downside Combined Cadet Force (CCF) and is still active today. (Historic England Archive)

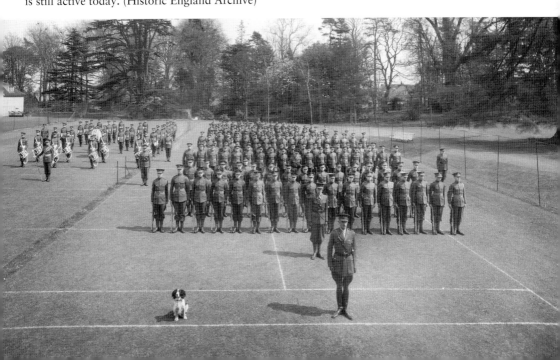

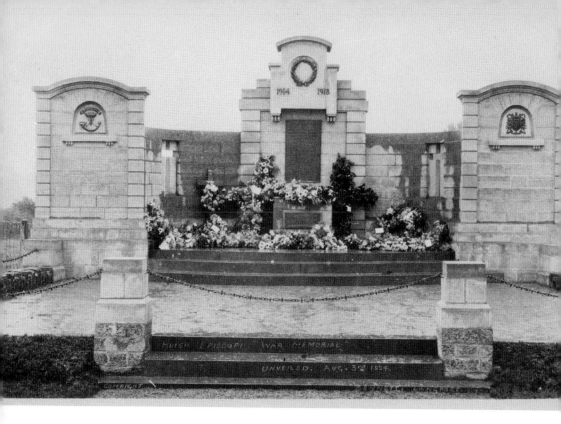

Above: Huish Episcopi First World War Memorial
Like most towns and villages across the county, the years after the First World War saw memorials erected to commemorate those who had lost their lives in the conflict. Fifteen men are listed on this memorial and a further nine names were added after the Second World War. (Historic England Archive)

Opposite: Nunney Castle
Located in the village of Nunney, the castle was built in 1373 on the site of a manor house by Sir John de la Mare, a local knight, in response to the possibility of a French invasion. It is essentially a three-floor tower keep surrounded by a moat. The external walls are still standing in much the same condition as when first constructed. With walls over 2 metres thick and rising up to 16 metres in height, it is an impressive structure that once had living quarters, a kitchen, a hall, a chapel and even an armoury. There was a drawbridge across the 3-metre-deep moat, which would have made any potential attack very difficult. Of course, the feared French invasion never happened and the castle was used as an impressive home, receiving various redesigns over the years, providing those inside with a life of luxury. At the start of the Civil War in 1642 a Royalist army was garrisoned at Nunney Castle and in 1645 a Parliamentarian army opened fire with cannons in an offensive that breached the castle walls and forced those inside to surrender. This was the only real military action that Nunney ever saw, with the castle swapping hands numerous times over the next few centuries, before gradually falling into a state of ruin and disrepair with ivy covering its walls and stone being taken by local people. The 1948 aerial photograph shows the ruined shell that remains, with sadly very little left of the internal rooms. (© Historic England Archive. Aerofilms Collection; © Historic England Archive)

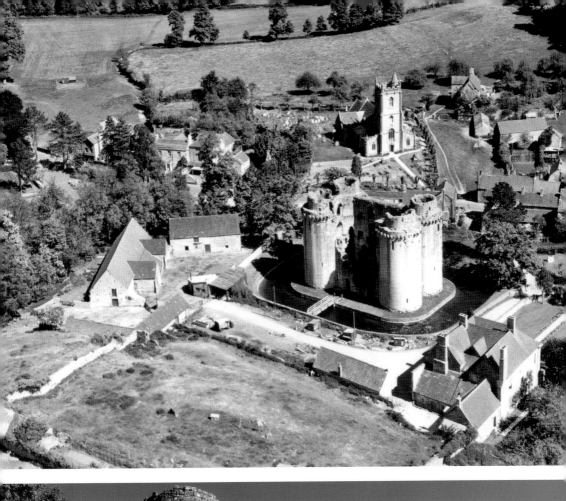
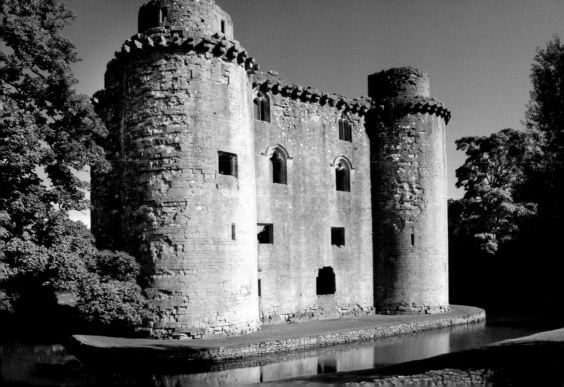

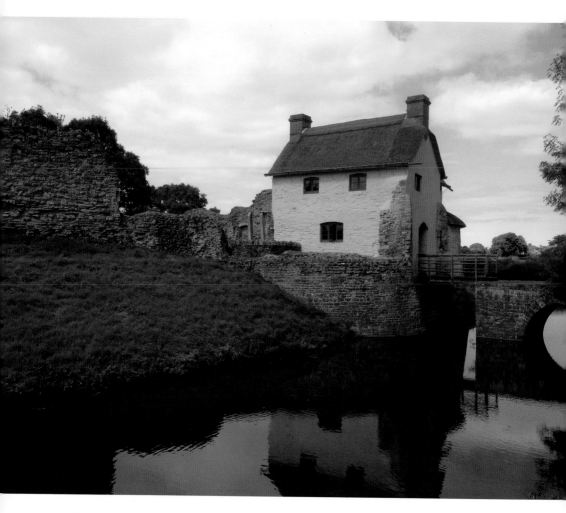

Stogursey Castle
Built by the de Courcy family in the twelfth century, Stogursey Castle is a motte-and-bailey-designed base surrounded by a water-filled moat. During the First Barons' War it was controlled by King John of England and the castle inexplicably survived two orders for it to be destroyed – first in 1215 and again in 1228. The site was eventually bought and the stone parts of the castle extended by the Fitzpayne family in 1300, who held it for nearly 200 years before it was destroyed during the Wars of the Roses in the 1450s by the House of York faction. Since then this scheduled monument has largely lay in ruins, although the moat still has water and the gatehouse, which was the least ruined of the castle, was rebuilt and restored by the Landmark Trust into a liveable dwelling, which is now used as a holiday let. (Author's collection)

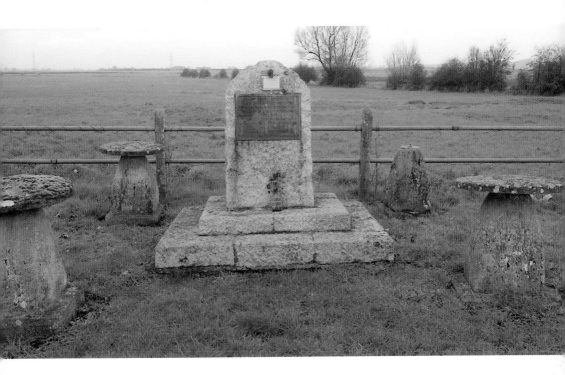

The Battle of Sedgemoor, Westonzoyland

On 6 July 1685 the last battle fought on English soil took place – the Battle of Sedgemoor. After a series of fights and skirmishes across the south-west of England, the approximately 3,500-strong rebel force of James Scott, 1st Duke of Monmouth, were trapped in Bridgwater on 3 July 1685 by the royal army of James II. With nowhere to go, the Duke of Monmouth decided to get on the front foot and launched a surprise night-time attack on the king's men. While navigating across the open moorland with its numerous deep and dangerous rhynes, some men startled a Royalist patrol, who in turn alerted the rest of the Royalist force. It is no surprise that the professional training of the regular army defeated the ill-equipped rebels, with over 1,200 being killed, compared to approximately 200 of the king's men. Some 500 rebel soldiers were taken prisoner and held in St Mary's Church in the village. Other men were not so lucky, with those found to be hiding being strung up in gibbets along the sides of the village roads as a warning to all who questioned the rule of the king. After initially escaping, James Scott was soon captured in Hampshire and taken to the Tower of London, where he was beheaded. James II sent Lord Chief Justice Jeffreys to round up any of Monmouth's supporters, and tried them at Taunton Castle in the Bloody Assizes. Most were found guilty, with the lucky ones being transported abroad and the rest executed. Today, the village church has a permanent display dedicated to this event and around the village are a series of information boards, along with a walk that leads down to the site of the battle. The isolated farmland remains as it did all those years ago, with a small monument at the spot; it is difficult to imagine the bloodshed that once happened here. (Author's collection)

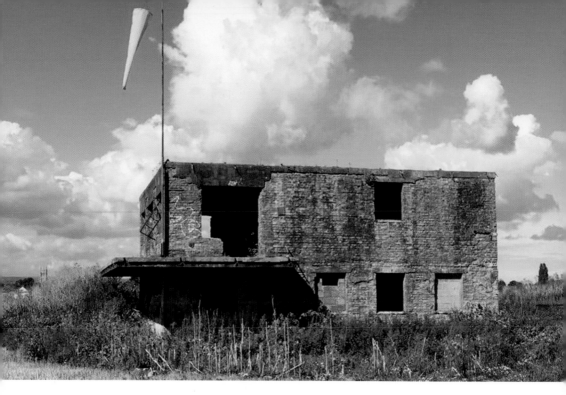

RAF Westonzoyland

Constructed in 1925, RAF Westonzoyland was used sparingly in the first ten years of its existence, but during the Second World War the A372 was closed and diverted south in order to allow the airfield to be significantly upgraded to 'bomber standard', with three concrete runways and a whole range of associated buildings being added. With its new status as a Class A airfield, the United States Airforce (USAAF) took control and the 442nd Troop Carrier Group operated from the base using the Douglas C-47 Skytrain to drop troops and equipment into northern France in the months after D-Day until October 1944. From this point until the end of the war a number of RAF squadrons had brief stays at the airfield, with the village becoming accustomed to seeing a whole range of different aircraft coming and going. In the years after the war RAF Westonzoyland became largely redundant, until the early to mid-1950s, when the Cold War threat saw the airfield in use once again as a training base for aircrews aboard Meteors and Vampires. By 1958 the airfield was once again disused and when it was released from military use in 1968, the A372 was restored to its original location along the route of the main runway. Today, the runways are still evident at the site, as are the derelict remains of the control tower and a whole host of other buildings. (Author's collection)

Bomb Damage in Yeovil

During the Second World War, the people of Somerset suffered their share of enemy air raids. Yeovil was attacked on ten occasions, with forty-nine civilians losing their lives as a result. This photograph shows the exterior of Church House showing bomb damage after one of the raids. (Historic England Archive)

Acknowledgements

For a history enthusiast like myself it has been an absolute pleasure to explore the huge photographic archive held by Historic England, and it was a difficult job to choose which photographs to include. A big thank you to Nick Grant, Jenny Stephens, Marcus Pennington, Becky Cousins and everyone at Amberley Publishing for their continued help, support and enthusiasm for my writing over the last few years. Most importantly, thank you to my wife Laura and sons James and Ryan who lost me to many days and evenings of research, which enabled this project to come to fruition. I have supplemented some additional photographs to the Historic England ones used in this book and these have been acknowledged accordingly in the photograph caption.

About the Author

Andrew lives in Somerset with his wife and two young sons. He has written a number of books on local and military history and is also proud to have had children's fiction books published. Andrew has been on BBC Radio Bristol, as well as a guest speaker and lecturer at a number of events and literary festivals. With more books and events planned, it is possible to keep up with everything he is up to by following him on social media or by visiting his website at www.andrewpowell-thomas.co.uk.

Also available from Amberley Publishing:
The West Country's Last Line of Defence: Taunton Stop Line
Somerset's Military Heritage
50 Gems of Somerset

About the Archive

Many of the images in this volume come from the Historic England Archive, which holds over 12 million photographs, drawings, plans and documents covering England's archaeology, architecture, social and local history.

The photographic collections include prints from the earliest days of photography to today's high-resolution digital images. Subjects range from Neolithic flint mines and medieval churches to art deco cinemas and 1980s shopping centres. The collection is a vivid record both of buildings that are still part of everyday life – places of work, leisure and worship – and those lost long ago, surviving only in fragile prints or glass-plate negatives.

Six million aerial photographs offer a unique and fascinating view of the transformation of England's towns, cities, coast and countryside from 1919 onwards. Highlights include the pioneering photography of Aerofilms, and the comprehensive survey of England captured by the RAF after the Second World War.

Plans, drawings and reports provide further context and reconstruction artworks bring archaeological sites and historic buildings to life.

The collections are housed in a purpose-built environmentally controlled store in Swindon, which provides the best conditions to preserve archive items for future generations to enjoy. You can search our catalogue online, see and buy copies of our images, as well as visiting our public search room by appointment.

Find out more about us at HistoricEngland.org.uk/Photos
email: archive@historicengland.org.uk
tel.: 01793 414600

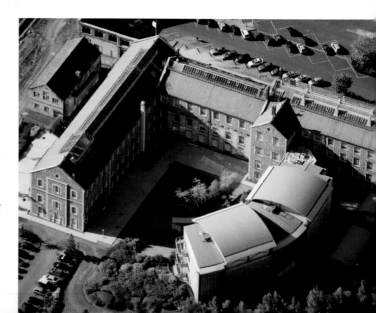

The Historic England offices and archive store in Swindon from the air, 2007.